The Campus History Series

AUBURN

PLAINSMEN, TIGERS, AND WAR EAGLES

TIGER TRACKS. Tiger pawprints decorate the Auburn campus. Pawprints guide motorists up interstate ramps toward campus and through drive-up window services at restaurants. Every year, the cheerleaders paint a large pawprint in the center of the Toomer's Corner intersection. Pawprints can be seen on other roads and in parking lots. Local businesses often incorporate pawprints in floor and wall designs or painted on windows during campus events such as homecoming.

Cover Caption: These Auburn students visit on the steps of Ross Hall between classes in the early 1940s. When Ross Hall was renovated, the doors pictured here were salvaged and can be seen at the entrance of Village Antiques in Auburn.

The Campus History Series

AUBURN

PLAINSMEN, TIGERS, AND WAR EAGLES

ELIZABETH D. SCHAFER

ARCADIA
PUBLISHING

Published by Arcadia Publishing
Charleston SC, Chicago IL, Portsmouth NH, San Francisco CA

Printed in the United States of America

Library of Congress Catalog Card Number: 2003109548

For all general information contact Arcadia Publishing at:
Telephone 843-853-2070
Fax 843-853-0044
E-mail sales@arcadiapublishing.com
For customer service and orders:
Toll-Free 1-888-313-2665

Visit us on the Internet at www.arcadiapublishing.com

In memory of Liberal Arts Dean

Dr. Gordon C. Bond (1939–1997), mentor and friend;

Dedicated to Mike Spann, Marjorie Champion Salamone,

Lynn Edwards Angell, and all of Auburn's heroes

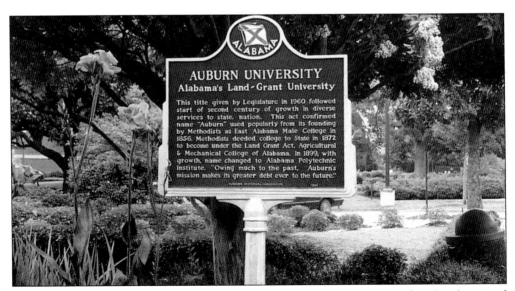

This most recent historical marker at Ross Square introduces visitors to Auburn's educational significance. Located at the heart of Auburn's beginnings, the marker inspires reflection on Auburn's past and aspirations for its future.

CONTENTS

ACKNOWLEDGMENTS

With gratitude to my parents, Dr. Robert and Carolyn Schafer; my grandmother Eunice Henn; Sean Fitzgerald Allen; Connie Moon; Dr. Thomas L. Smith; Anne Amacher; Lee Cannon; Melissa Denney; Joanne Clark; Todd Van Emst, for his photograph of President George W. Bush at Auburn; Dr. Royce and Shirley Beckett; Faye Lawrence and the late Dr. John M. Lawrence; Dr. Randall and Margaret Clark; Dr. Rodrigo and Dorothea Rodriguez-Kabana; Carolyn and Greg Williams; Dr. Frank L. and Dot Owsley; Carl and Jessie Summers and the Lee County Historical Society Museum; Dr. Jane B. Moore; Dr. Harriet Giles; Dr. Louise Turner and the late Frank Turner; the late Dr. William W. Putney; Dr. Phyllis Hickney Larsen; Dr. Alice Taylor-Colbert; Gina Fromhold; Nancy Moran; Dr. John and Randy Cottier; Dr. Paul and Peggy Turnquist; Dr. Howard and Carolyn Ann Carr; Chris Danner; Dick Salmon; Dr. Buddy Bruce; Dr. John and Janice Saidla; Tonya Spann Ingram and the Spann family; the family and friends of Lynn Angell; Julia Freeman; Hubert and Lillian Champion and the Salamone family; Dr. Charlotte Ward; Ruth Ann Nunn Bond; Peppi and Fran Verma; the Alabama Department of Archives and History; the Auburn History Department and College of Liberal Arts; the Auburn library, especially Archives and Special Collections and staff including Dr. Dwayne Cox, Joyce Hicks, Stephen Dole, John Varner, Dieter Ullrich, Brenda Prather, Paul Martin, David Rosenblatt, Bev Powers, Alfrieda Brummit, Peter Branum, Michael P. Morris, Marty Olliff, Debbie Fletcher Etheridge, Andrew Adams, Brenda Ray, Mary Hammett, Claudine Jenda, Dottie Marcinko, Virginia Palmer, and the late Grady "Gene" E. Geiger; my Auburn friends; everyone who has made, preserved, and recorded Auburn history; and Auburn people I've encountered in my travels to such places as Thailand, home of many fisheries alumni; St. Kitts, where the Ross University veterinary dean is an Auburn alum; and Seoul, where I was greeted with "War Eagle!"

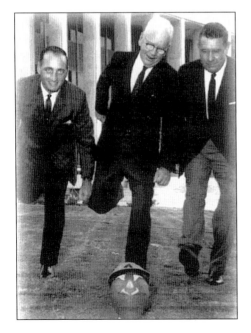

KICKOFF. Vince Dooley '54, President Draughon, and Coach Shug Jordan pretended to kickoff a decorated football to promote a new football season in 1963. Dooley, who earned a master's degree in history from Auburn in 1963, played football for Auburn before having a victorious career as head football coach and athletic director at Georgia.

INTRODUCTION

"Being an Auburn man is the greatest honor of my life," alumnus George Roy Corcoran '16 wrote decades after his graduation. Most Auburn alumni feel the same way.

The Plains is known for its warmth, caring, and generosity. Auburn people live Prof. George Petrie's "Auburn Creed," which emphasizes the need to be practical and hard working. Auburn people are innovative, perseverant, and determined, using their talents to shape Auburn's campus and create opportunities for the future of the Auburn community. Most of all, Auburn people believe in Auburn.

Auburn president Dr. Harry Philpott told freshmen in 1965, "This is an institution dedicated to searching for the truth wherever it may be found." He stressed that the Auburn community has a "sense of worth and purpose" and urged the freshmen to safeguard the Auburn spirit, which "is a spirit of friendliness, of people speaking to one another on the campus; it is a spirit of helpfulness, of unselfish service." Auburn registrar Charles W. Edwards '20 defined the Auburn spirit as "that extra spark of life, that controlling quality or idea, that source of energy and courage, that sense of belonging and of loyalty and devotion, which is shared by every Auburn" person.

Friendship is paramount to the Auburn spirit. Auburn people support each other. Auburn nurtures imagination and innovation. Auburn people believe anything is possible and dare to dream and explore. People are dedicated to Auburn throughout their lives. Albert A. Hedge '11 wrote the following to the alumni association in 1948: "I've kept my figure and have the old Orange and Blue sweater with the football 'A' still in moth balls ready for any emergency."

Auburn inspires its community to aspire to becoming the best. "I have great pride in the fact that I am an Auburn graduate," Dr. Ralph B. Draughon '22 stated in his 1962 President's Message. "I know I received a good education here—one that has sustained me and allowed me to compete."

Auburn is rich in the number of outstanding people associated with it. Auburn people have accomplished so many wonderful things that it would be impossible to document them all in one book. Thousands, perhaps millions, of pages and images would be necessary to document Auburn's history thoroughly. Soon after she won the 2003 Miss Alabama pageant, Catherine Crosby, Class of 2002, told *The Plainsman*, "When you bleed orange and blue, you are certainly destined to lead a life of success."

Auburn people have achieved on campus, in their homes and communities, and beyond, leaving an impact on others nationally and globally. Anywhere you go, even the remote corners of the world, you are likely to run into an Auburn person. Wander across campus, and you'll see names of buildings that memorialize people whose lives touched Auburn. Auburn produces leaders, intellects, artists, athletes, beauties, and entrepreneurs. Auburn people often have a family legacy of sharing an Auburn affiliation. Current students can sentimentally visit Samford Hall, where their parents or grandparents might have proposed after courtships at other Auburn landmarks, reenacting similar activities such as watching free movies at Langdon Hall, rooting for teams at stadiums and fields, or sipping lemonade at Toomer's Corner.

Auburn produces outstanding CEOs including *Time*'s Don Logan; internationally known humanitarians such as Millard Fuller; gifted writers such as Anne Rivers Siddons, Ace Atkins, and Richard Marcinko; and popular musicians such as Jimmy Buffett and Bill Morganfield. Auburn people cheer when Auburn astronauts liftoff at Cape Canaveral and are guided through their missions by Auburn engineers and scientists at Houston's Johnson Space Center and NASA facilities nationwide. The Auburn community reveres its well-known members, including Charles

Barkley, Bo Jackson, and Toni Tennille. Less well-known but equally achieving Auburnites include inventors who make daily life easier and more comfortable and an Auburn man, appropriately named Auby, who was Charles Lindbergh's flight instructor.

I have been preparing to compile this book my entire life. I grew up in Auburn, where both my parents were on the faculty. I attended the Child Study Center, earned three degrees from Auburn, and worked in the university's archives. I've explored the campus and been in almost every building on campus. I've known many of the people featured in this book. I've experienced the joy of hearing goods news about Auburn and its people, the delight of discovering previously unknown nuggets of Auburn information in old records, the thrill of getting goose bumps when Auburn athletes stand on podiums to receive Olympic medals, and the pride when Auburn is mentioned in books such as *To Kill a Mockingbird*.

I intend for this book to be fun, nostalgic, and celebratory of Auburn. This work offers readers glimpses into Auburn's history that will depict both familiar traditions and surprises, which will deepen your love for Auburn. During my research, I discovered Auburn people whose stories and achievements will intrigue, entertain, and inspire readers. Everyone has his or her favorite Auburn moments and memories. As Auburn prepares to celebrate its sesquicentennial in 2006, I hope Auburn people everywhere reminisce about Auburn and preserve their recollections, images, and/or artifacts of days on the Plains for possible contribution to Auburn's archives, enhancing its collections for future histories.

This book is a tribute to everyone who loves Auburn. Enjoy, and War Eagle!

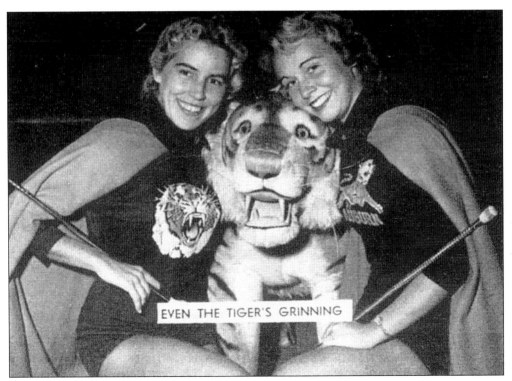

EVEN THE TIGER'S GRINNING

MASCOT. Stuffed tigers were often seen around campus in dorm rooms and accompanying students. Before Aubie was created and a live eagle soared in the stadium, plush substitutes were used. These majorettes and tiger seem pleased with Auburn's winning 1957 football team.

One

HISTORY

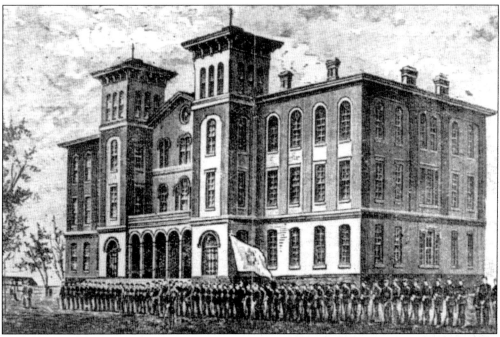

OLD MAIN. Auburn University began as the East Alabama Male College (EAMC), a private Methodist liberal arts school, which was founded at the village of Auburn in 1856. Students and faculty usually referred to the school as Auburn instead of its lengthy formal name. The EAMC's primary administrative and classroom building was called Old Main. Built on what is now considered Auburn's historic core, Old Main was the center of student activity. When classes were first offered in 1859, 6 faculty members taught 80 students. EAMC closed during the Civil War when most of its student body and faculty volunteered to serve for the Confederacy. Old Main and the school's chapel across the street were used as hospitals for wounded and sick soldiers. Classes resumed in 1866. After Alabama legislators designated Auburn the state's public land-grant institution, Alabama Agricultural and Mechanical College (Alabama A&M), in 1872, Old Main continued its central academic role on campus. An 1887 fire razed Old Main.

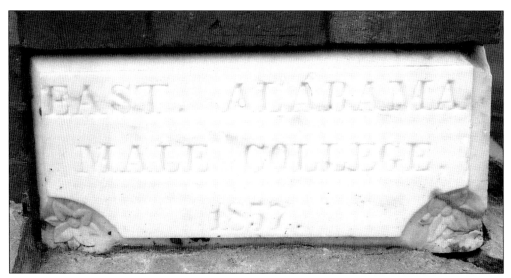

CORNERSTONE. A white marble stone at the foot of Samford Hall's northeast corner commemorates Auburn's origins. The name "East Alabama Male College" is carved into the stone. Flowers are etched at the stone's lower corners with the date 1857, when the stone was prepared. Salvaged from the fire, the stone was incorporated into construction of Samford Hall, Auburn's most recognizable landmark, on the site where Old Main stood.

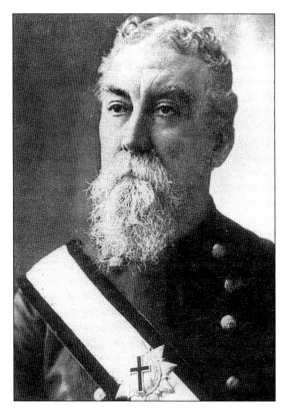

EARLY CADET. Henry Clay Armstrong studied at EAMC prior to the Civil War. A lawyer, he enlisted and served as a captain for the Confederate army. His post-war career was impressive. Armstrong was a state legislator, speaker of the Alabama House of Representatives, and state superintendent of education. U.S. President Grover Cleveland appointed Armstrong consulate general to Brazil. After he returned, Armstrong served on Auburn's board of trustees and its executive council. His son, Henry Clay Armstrong Jr., taught history and English at Auburn.

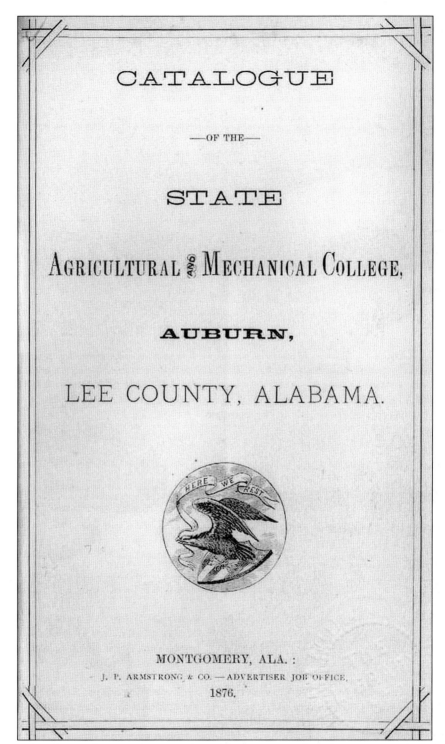

CATALOGUE

—OF THE—

STATE

AGRICULTURAL AND MECHANICAL COLLEGE,

AUBURN,

LEE COUNTY, ALABAMA.

MONTGOMERY, ALA. :

J. P. ARMSTRONG & CO.—ADVERTISER JOB OFFICE,

1876.

COURSES. This first college catalogue explained requirements for admission, stated professors' credentials, and told students which courses were available. Annually, students consult Auburn's detailed catalogues to choose fields of study and classes.

ADVERTISING. Auburn's administrators distributed flyers and placed advertisements in print media to attract students. These advertisements highlighted benefits of an Auburn education, especially scientific endeavors. Modern students and parents would probably be dismayed at the bold statement in all-capital letters promising cadets free tuition in this 1883 advertisement. Parents were probably reassured that Auburn was concerned about their sons' moral well-being and health. This notice reveals that young students, usually referred to as sub-freshmen, were allowed to enroll at Auburn to prepare for collegiate courses.

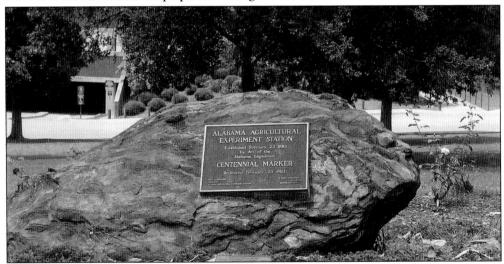

EXPERIMENT STATION. This boulder outside Comer Hall on Ag Hill commemorates the centennial of the founding of the Alabama Agricultural Experiment Station in 1883 at Auburn. The marker, known as Buchanan's Boulder, exemplifies Auburn's history as a land-grant institution dedicated to agricultural and mechanical endeavors. Auburn researchers have investigated how to better agriculture for farmers and consumers in Alabama and beyond by developing new methods, technology, and crops. Agricultural representatives placed a time capsule at this site in 1985 to be opened a century later.

IMAGE. Old Main was a popular design printed on material related to campus activities such as this debate invitation. The literary societies involved in this yearly competition maintained their libraries in Old Main, where they met and practiced.

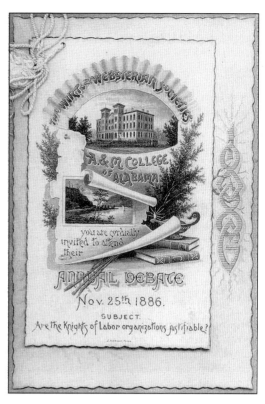

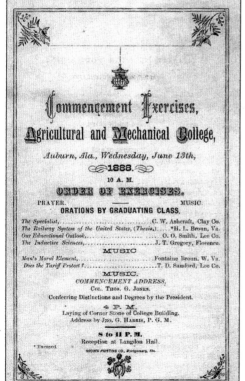

PROGRAM. Early Auburn graduation programs were elaborately carved documents which outlined schedules, prayers, appearances by notable speakers, student speeches and thesis presentations, musical performances, and receptions. This invitation is significant because it is for the first graduation ceremony after Old Main was destroyed, which included the cornerstone laying of the new Samford Hall.

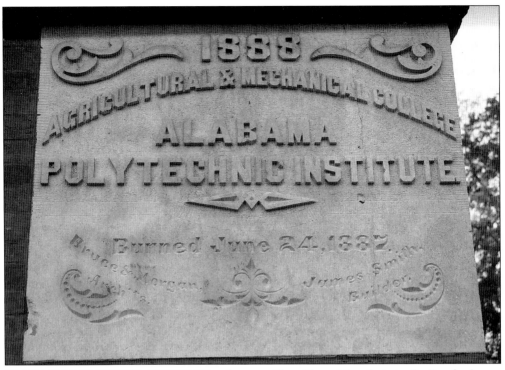

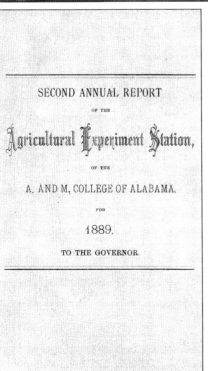

SAMFORD HALL. Named in tribute to the Samford family, who has enhanced Auburn for generations, Auburn's best-known building proclaims its history to passersby. An elaborately engraved stone at eye level on the building's northeast corner indicates who designed and directed construction of the building that replaced Old Main in 1888. Samford Hall was built with only one tower in comparison to Old Main's two prominent towers. Beneath that stone, a plaque indicates that the site had been the location of a Confederate hospital. Samford Hall has been renovated to maintain its historic structure and appearance. It is one of the most photographed sites on campus, especially at graduations and during football seasons. Auburn students attended liberal arts classes in Samford until the 1960s. The building now houses administrative staff and executives, including the president's office and conference rooms for the board of trustees. Samford's bells chime throughout the day.

REPORTS. In the late 1880s, researchers at Auburn's Agricultural Experiment Station began issuing official reports to Alabama's governor, the chairman of the school's board of trustees. These documents contain scientific information and statistics that are useful to determine how Auburn agriculturists shaped and influenced the state's commercial agriculture.

MISSION. As this illustration from an early Auburn yearbook indicates, the Auburn community stressed three components of education, research, and extension to achieve its land-grant institutional mission. Faculty members were expected to teach and initiate investigations in their specialties. Students were encouraged to apply knowledge and life skills they acquired in classrooms and laboratories to their careers and lives. Agricultural staff developed extension services to spread information gained at the Auburn experiment station for practical use in fields in Alabama and the South.

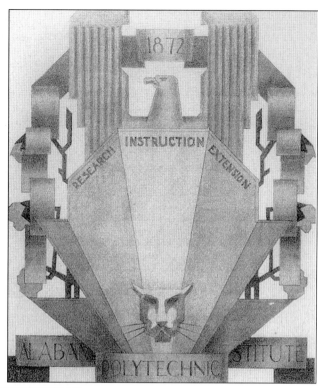

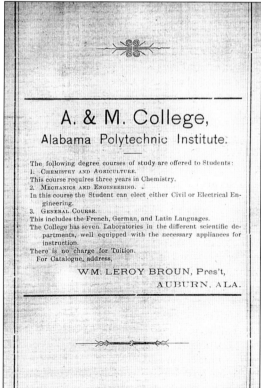

NAME CHANGE. Before the state legislature formally changed Alabama A&M's name, people called the school Alabama Polytechnic Institute, and school letterhead and publications referred to Auburn by that name. In this advertisement, college president William Leroy Broun emphasized Auburn's engineering and science offerings. Broun transformed Auburn into an acclaimed scientific school and encouraged innovative research and instruction. Students flocked to Auburn to study engineering. Newspapers reported achievements at Auburn, including the first cotton ginned by electricity and the first X-ray experiments in the South. Auburn professors displayed their research at the Atlanta Exposition and other forums promoting technological progress. To reflect the school's expanding curricula and enrollment, Alabama A&M was officially renamed the Alabama Polytechnic Institute (API) in 1899.

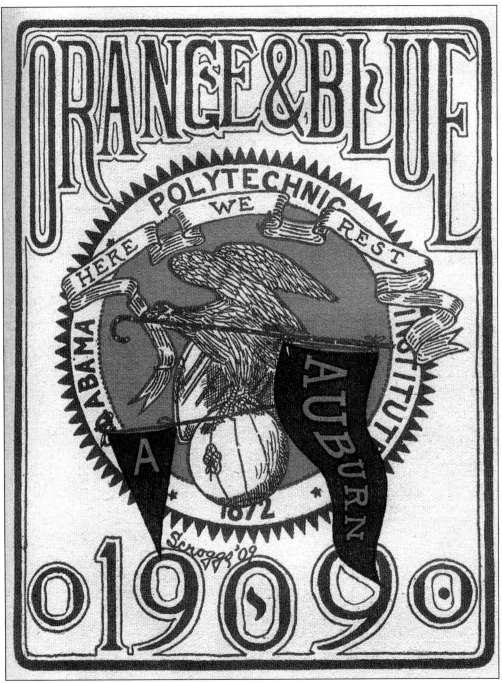

ART. Students delighted in portraying Auburn artistically. The 1909 *Glomerata* printed this illustration, which depicted themes and images that have persisted throughout Auburn's history.

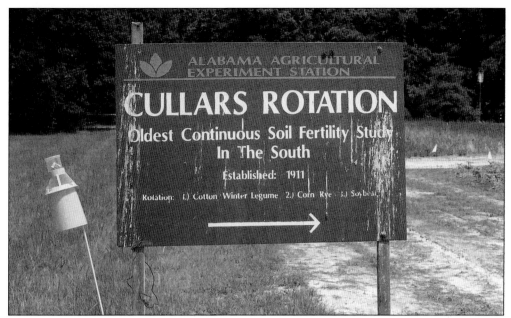

CONTINUITY. Modern Auburn's agriculturists have continued experiments initiated by their scientific predecessors. The Cullars Rotation, behind Auburn's art museum, was begun 15 years after Prof. John F. Duggar established the "Old Rotation" experiment, which is America's longest-enduring, continuous cotton investigation, in 1896. A historical marker is placed by the Old Rotation field adjacent to the arboretum. In the 1890s, Prof. George F. Atkinson began investigating soil fertility on land owned by J.A. Cullars and J.P. Alvis southeast of Old Rotation. The Alabama legislature funded the ongoing experiments in 1911. Bessie Alvis Emerick and Lillian Alvis Miller sold the property to Auburn in 1938. Current scientists rotate crops in three-year cycles to determine long-term influences on soil qualities.

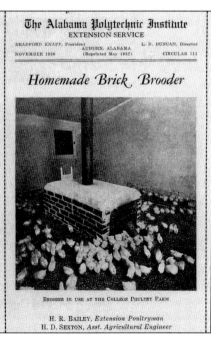

The Alabama Polytechnic Institute
EXTENSION SERVICE
BRADFORD KNAPP, President L. N. DUNCAN, Director
 AUBURN, ALABAMA
NOVEMBER 1930 (Reprinted May 1932) CIRCULAR 111

Homemade Brick Brooder

BROODER IN USE AT THE COLLEGE POULTRY FARM

H. R. BAILEY, *Extension Poultryman*
H. D. SEXTON, *Asst. Agricultural Engineer*

EXTENSION. As Auburn grew and received more federal and state funding, agricultural and home economics faculty and staff regularly produced extension service bulletins to spread Auburn's educational mission beyond the campus. Professors such as Dr. George Cottier, a poultry department faculty member who also earned a veterinary degree at Auburn, kept their colleagues' publications as guides in their research and their goal to seek solutions that people could realistically apply to farm and domestic situations. This brick brooder was especially practical during the Depression when many chicken farmers lacked money to invest in equipment.

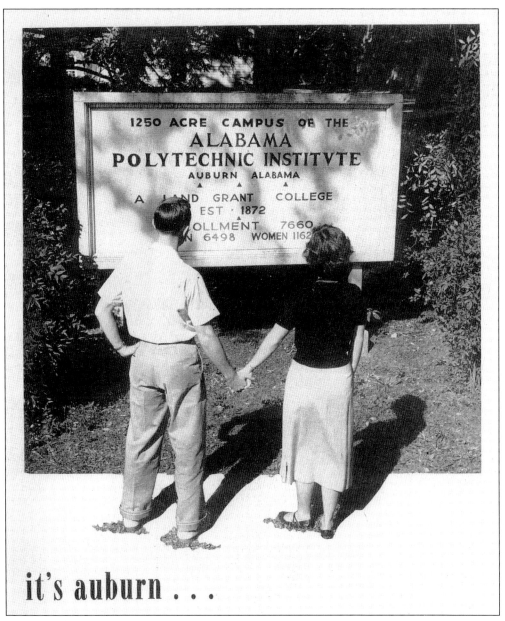

EXPANSION. These students examine a sign in the early 1950s that lists how Auburn's physical size and enrollment had increased a century after the EAMC had been chartered.

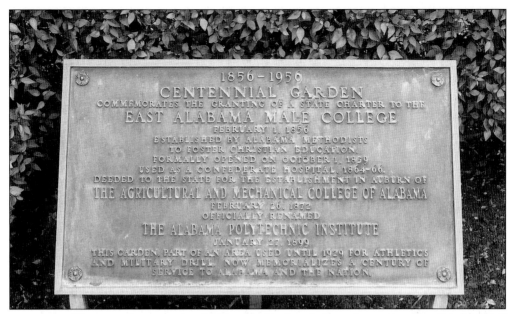

REFLECTION. This sign alerts people admiring the gardens in Ross Square between Samford Hall and Foy Student Union of Auburn's first 100 years. That site, which now has a rectangular brick turtle and fish pond and artistically landscaped plants, used to be the site of cadet drills and sporting events. Students have used the garden for dances, initiation stunts, studying, drawing, and other campus activities.

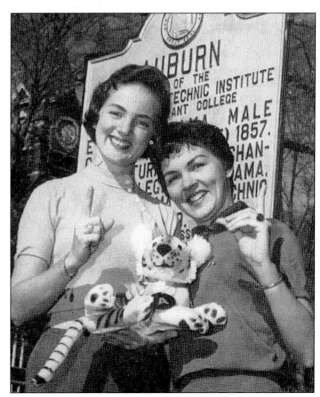

SCHOOL PRIDE. When Auburn won the 1957 football championship, these coeds posed with a tiger mascot by Samford Hall. The historical marker with Auburn's designation as the Alabama Polytechnic Institute is now preserved in the campus archives.

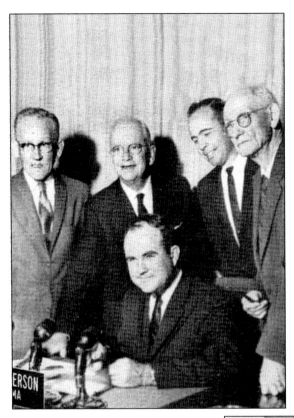

AU. By 1960, the Alabama Polytechnic Institute was formally designated Auburn University to indicate its growth and development of graduate programs. State and university representatives Paul S. Haley '01, tenth president Ralph B. Draughon, Sen. Rufus Barnett, and Jesse Harvey are shown at Gov. John Patterson's signing of the legislation on October 30, 1959, changing Auburn's legal name. Auburn's sixth president, Charles C. Thach, had foreshadowed the eventual renaming: "The Alabama Polytechnic Institute, a high sounding phrase, is fit for legal documents and grave legislation, but not to conjure with and not to yell and not to dream with as is 'Fair Auburn.'" Since the name change, Auburn's enrollment rapidly increased, attracting students from every Alabama county, all 50 states, and more than 100 countries, to become Alabama's largest university. Auburn's faculty and staff have increased proportionally, and new buildings are constructed and land acquired to meet educational demand.

GROUNDBREAKING. Auburn Trustee Paul S. Haley '01 is shown with members of his fraternity Kappa Sigma at the groundbreaking for Haley Center. That 10-story building adjacent to the the stadium, Quad Dorms, Cater Hall, Thach Hall, and other key buildings on campus altered student life. As enrollment soared after World War II, Haley Center accommodated increasing demand for core liberal arts classes required of all Auburn graduates. Liberal arts classes were shifted from Samford Hall to Haley Center. Departments were given entire floors to provide offices for faculty and graduate assistants. Education departments acquired space for teaching, laboratory, and media resources. The brick concourse, Eagle's Nest, university bookstore (http://www.aubookstore.com), and basement study and snack areas gave students new places to socialize.

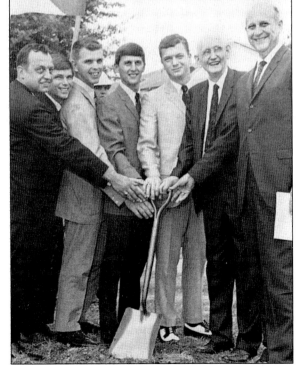

AUM. The Alabama legislature supported a $5 million bond issue in 1967 to build a branch campus of Auburn in Montgomery. Gov. Lurleen Wallace signed the act. Auburn University at Montgomery (AUM) opened in 1971. AUM is known for its academic excellence, especially in nursing and education programs. That branch campus retains close ties to Auburn's faculty, staff, students, and alumni on the main campus. For example, Auburn alumnus Bob Ingram '49 was honored with the position of Distinguished Lecturer at AUM in recognition of his journalism achievements.

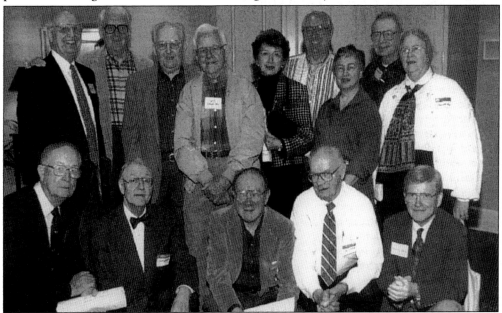

AUALL. Auburn's historic commitment to lifelong learning is exemplified by its programs for people, particularly retired faculty and spouses who are not enrolled in degree courses. Auburn University Academy Lifelong Learners (AUALL) offers classes representing varied interests, including church music, film, sciences, and photography. A steering committee established AUALL with the leadership of Mary Burkhart and Cayce Scarborough. Spring 1996 study group coordinators are pictured, from left to right, as follows: (front) James Hubbard, Jacob Walker, Laurence Morgan, Jay Sanders, and Foster Owen; (back) John Fries, Henry Henderson, Alex Stewart, Cayce Scarborough, Norma Smock, James Koczman, Sarah Wiggins, Marshall Baker, and Charlotte Ward.

INAUGURATION. When a new president is chosen to represent Auburn, an inauguration ceremony officially installs the executive. Faculty are selected to represent their alma maters during the procession. Auburn alumnus Dr. James E. Martin '54, Auburn's 14th president, enhanced Auburn with the construction of several major buildings, including the significant expansion of Ralph B. Draughon Library, the construction of an Olympic-caliber aquatics center, which was named in his honor, and the university's hotel and Dixon Conference Center. The pool has enabled Auburn to host national swim meets and international competitors training to compete in the United States. The conference center has resulted in Auburn being chosen for conferences, ranging from local to international meetings, and attracting notable speakers to campus.

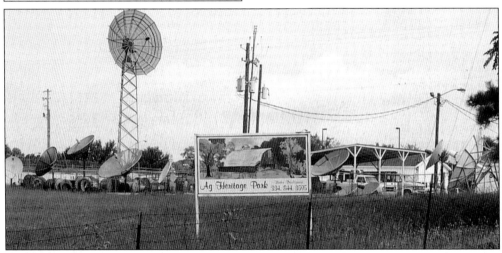

HERITAGE PARK. The Agricultural Heritage Park is a work in progress across from athletic facilities on Samford Avenue. Planners aspire to restore The Old Red Barn, which was the campus milking parlor built in 1929. The park will celebrate Auburn's agricultural history with exhibits and a visitor's center where people can buy dairy refreshments. The site will have a pavilion, amphitheater, fishing ponds, indigenous animal and plant areas, and a walking trail to the Old Rotation field and historically significant agriculture sites on campus. The Alabama Agricultural Hall of Honor will be moved from Comer Hall to the park. Associate agricultural dean Richard Guthrie declared, "Ag Heritage Park will be a monument to the contributions Auburn has made to agriculture and that agriculture has made to Alabama, as well as to the role that agriculture has played at this university." The satellite dishes in the background emphasize Auburn's commitment to technology, especially how it can enhance agriculture and expand communications for research and instruction globally.

22

Two

CAMPUS SCENES

WELCOME. This large sign greets people who explore the oldest part of Auburn's campus. Before every graduation ceremony, long lines form as people wait to take pictures of graduates in front of this sign. To the right, Langdon Hall sits between Samford Hall and Hargis Hall, which houses the graduate school's dean and staff. Originally built in 1853 as the Auburn Masonic Female College's chapel, Langdon was moved to campus when Auburn officials purchased the structure in 1883. Langdon has been utilized for a variety of purposes, including political speeches. Many famous people have visited Langdon. Students have enjoyed free movies and other entertainment in that building. A plaque in Langdon honors Auburn's contributions to Civil War service.

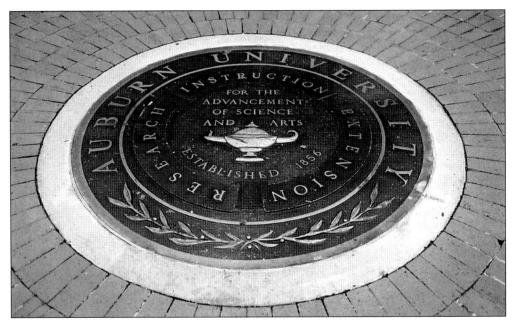

AUBURN SEAL. Auburnites carefully step around the large Auburn seal set in the brick sidewalk outside Langdon Hall. A small plaque adjacent to the seal states: "Given for the Betterment of Auburn 1999."

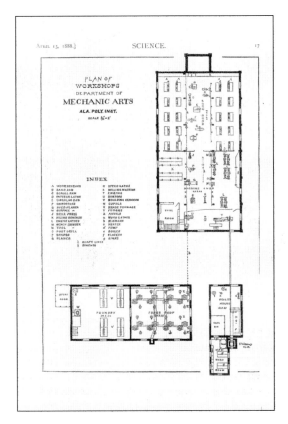

MECHANICAL ARTS. In April 1888, *Science* magazine featured the mechanic arts workshops directed by Massachusetts Institute of Technology alumnus George H. Bryant at Auburn. The article described the organization of that department in 1885 and what machinery and tools were procured. It also discussed the buildings, including a foundry and woodshop. The three-year curriculum was outlined. At that time, approximately 90 students enrolled in those courses annually. Auburn's scientific resources gained national and regional publicity.

SNOWDAY. Snow is a rare occurrence at Auburn, and most Auburn students have never experienced significant snowfalls except for skiing vacations. Sometimes on exceptionally steely gray, chilly days, students catch a glimpse of a snowflake or two in the air. These turn-of-the-20th-century students delighted in this snowfall coating campus. Other significant flurries descended on Auburn in 1973 and 1993. Classes were cancelled, and students indulged in a snowy vacation from schoolwork. Impromptu snowball fights broke out and snowmen dotted campus. Cafeteria trays served as sleds to glide down hills on campus. Other natural disasters have paralyzed campus, such as Hurricanes Frederick and Opal.

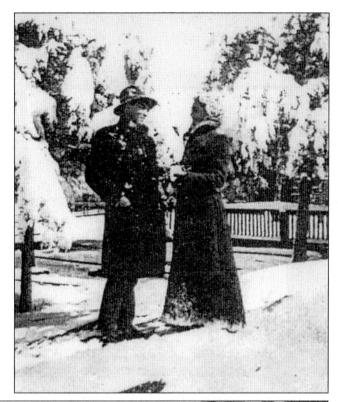

TOOMER'S CORNER. These students pose at the entrance to campus on the southwest edge of Toomer's Corner in the early 1900s. In the background, an automobile passes the site of Auburn's legendary Toomer's Drugstore. Because of the cadet's dress, their number, and the fact that they are holding shovels, they are probably participating in an initiation, perhaps for Spades, Auburn's elite honorary club for seniors. Spades has existed since *c.* 1915, and members select their successors based on leadership.

MARY MARTIN. Mary E. Martin Hall, built in 1910, has had several purposes on campus. Many alumni will remember it being a library, while others have only seen it used as an administrative building for the registrar. Mary Martin served Auburn as librarian for several decades in the 20th century. She grew a garden behind the library and used a hose to spray ROTC students running a shortcut through that area from boarding houses to the drill field. History professor Dr. Joseph Harrison enjoyed telling how in the 1950s he was locked inside that library during a football game and escaped by climbing out a window onto a ledge and shimmying down a tree.

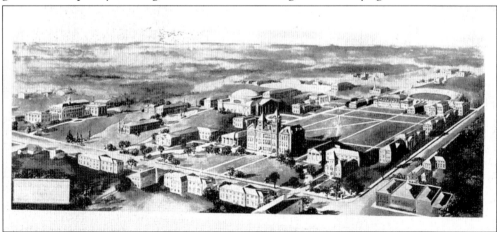

PANORAMA. The 1923 *Glomerata* printed this artistic rendition of Auburn's campus as officials planned for it to look after revenues from the Greater Auburn Campaign financed construction of buildings. At that time, engineer Erskine Ramsey donated $100,000, which was matched by Auburn patrons to build an engineering hall named in his honor. Notable absences include Ross Hall west of Samford Hall, not built until 1930, and the Quadrangle dormitories to the south, for which construction began in the late 1930s.

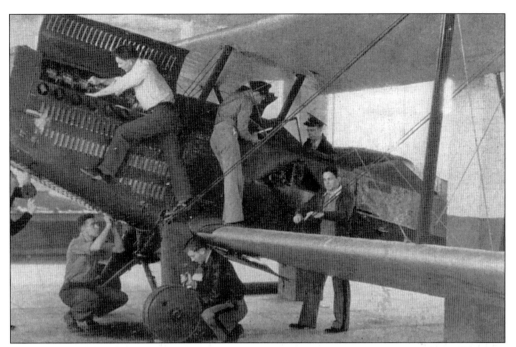

AIR MINDED. Auburn has a long history of providing aviation educational opportunities to its students. Aeronautical engineering became a popular major. Students, such as these pictured in the 1930s, benefited from having access to aeronautics laboratories to supplement their classroom lectures with practical experiences with aircraft. Students also could learn to fly at the municipal airport in the city of Auburn.

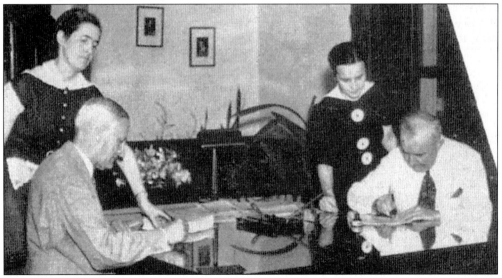

DIPLOMA SIGNING. At one time, Auburn's president and Alabama's governor signed every graduate's diploma. Ninth Auburn president Dr. Luther Noble Duncan '00 and Gov. Bibb Graves are shown signing diplomas in 1939 with the assistance of Berta Dunn and Mrs. Good. An honor graduate who had been senior class president when he was a student, Duncan was described as the "ever-friendly President of Auburn" whose administration witnessed large enrollment increases and building construction on campus.

Ross Hall. One of Auburn's most attractive buildings, Ross Hall opened in 1930 to house chemistry faculty, laboratories, and classrooms. The names of historically significant chemists are engraved in large stones on this building. After decades of use, Ross Hall underwent renovation and became home to chemical and mechanical engineering personnel. The distinctive cupola was restored after being struck by lightning in the early 21st century. One of the most stunning views of Ross Hall can be seen by driving north on Mell Street from the President's Mansion.

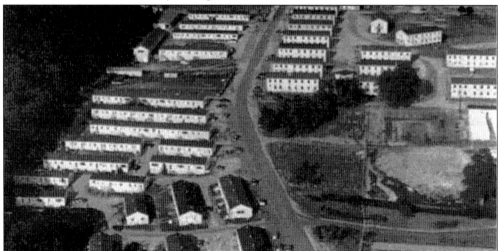

Graves Center. During the Depression, Public Works Administration workers built cottages along Samford Avenue where the current male athletic dorm Sewell Hall, Telfair Peet Theater, Hill dormitories, and music, fisheries, and forest buildings now stand. These cottages were used to house campus visitors. The arrival of World War II veterans using their G.I. Bill benefits to attend Auburn, and additional faculty and staff, created a housing crunch. Those families lived in the cottages as well as in additional buildings relocated from Florida. Graves Amphitheatre remains on this site. The National Soil Dynamics Laboratory can be seen in the southwest corner of this 1952 picture.

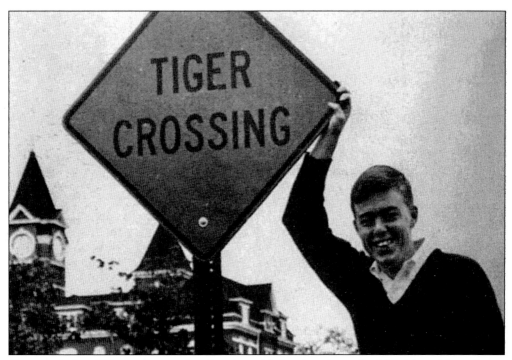

CAUTION. In the 1960s, students enjoyed posing with the sign pictured, which warned motorists to be cautious at crosswalks. *Tiger Cub* editor Mike Pugh '68, from Seattle, Washington, chose the sign as the backdrop for his Who's Who of American College and University Students photograph.

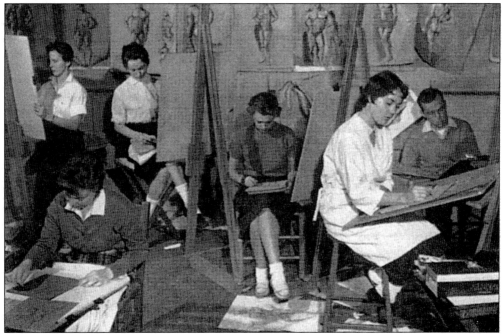

STUDIO. Some Auburn students and faculty were more familiar with the scenes of art studios than the campus landscape because of the hours they devoted to perfecting their creations and projects. These aspiring artists work on drawings in 1958.

SOIL DYNAMICS. In the 1920s, agricultural engineering department head Mark Lovel Nichols developed innovative research concerning soil reactions to interactions with wheels and implements. His findings altered how tires and tools on farm machinery and other vehicles, including the lunar rover, are designed. Because of Nichols's research, the federal government's National Tillage Machinery Laboratory (later renamed the National Soil Dynamics Laboratory) was built adjacent to campus across from the current Sewell Hall and west of the horticulture greenhouses and Hill Dorms. Researchers are adjunct Auburn faculty. Nichols won his profession's highest award, the Cyrus Hall McCormick Medal, which also was later presented to the laboratory's director Dr. Robert L. Schafer.

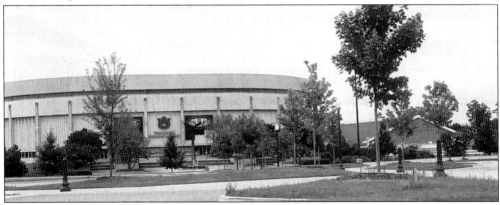

BEARD-EAVES MEMORIAL COLISEUM. In the late 1960s, this facility was constructed for basketball games, graduation ceremonies, and concerts. Built to honor Auburn servicemen who died in military service, the coliseum gained the name Eaves from acclaimed basketball coach Joel H. Eaves '37. The coliseum is a valuable part of students' lives. Before computer registration, students used to pick up forms and schedules in the coliseum. During inclement weather, students can jog around the coliseum's circular aisle. Students line up outside the coliseum to buy coveted concert and football tickets. A large billboard outside announces campus events. A regal eagle sculpture soars outside the building on which large tiger eyes watch passersby. The James E. Martin Aquatic Center, home of Auburn's national champion swimmers, can be seen to the right.

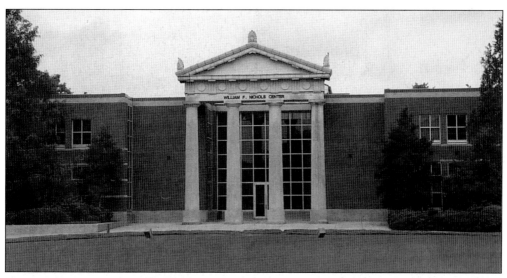

TRADITION. Thousands of Auburn engineering students devoted hours to learning their profession in Broun Hall. Named for the university president William LeRoy Broun, who focused on making Auburn a great engineering school, Broun Hall was a campus landmark until it was torn down in 1984 for the construction of Harbert Center. The columns of Broun Hall were saved from destruction to serve as the façade of the ROTC's Nichols Building, named in honor of Auburn's esteemed alumnus U.S. Sen. William F. Nichols, B.S. '39 and M.S. '41, who was a World War II veteran and champion of the armed services in Congress.

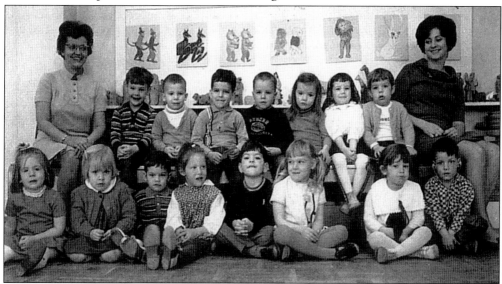

CHILD STUDY CENTER. The oldest early childhood laboratory in the South, Auburn University's Child Study Center, adjacent to Haley Center, has educated generations of children and university students since 1927. Education majors can earn credit for practice teaching and observing the implementation of innovative educational theories at the center. Children of Auburn faculty, staff, students, and alumni can apply to attend nursery school and kindergarten. Most of the members of this 1968 class of three-year-olds later graduated from Auburn University. Some Child Study Center alumni have held significant roles in the university community as students, faculty, and administrators.

TIGERS. In 2001, large fiberglass tigers appeared around campus and the city of Auburn for "Tigers on the Prowl." Inspired by Chicago's display of cows, the Auburn tigers were painted to represent different aspects of Auburn, such as a stars and stripes tiger in front of the fire department. One tiger even had an eagle beak and wings to depict Auburn's mascots. Tigers can be seen lurking by bushes and gazing from rooftops. As a prank, some students catnapped several of the tigers, which were returned intact after their adventure.

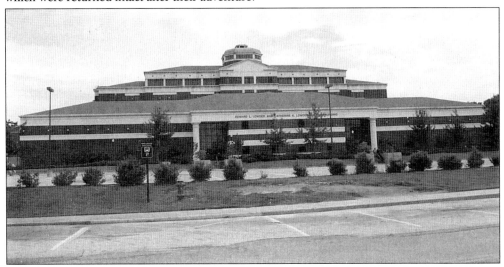

BUSINESS. The gold dome of the Edward L. and Catherine K. Lowder Business Building shines above Auburn's skyline. This Auburn trustee and his wife gave Auburn funds to construct a center for the College of Business. Built in the early 1990s on the site of the former Bullard and Magnolia Halls, the 158,000-square-foot Lowder Building gives Auburn's business community an impressive home that enhances its reputation as the producer of some of America's most successful executives.

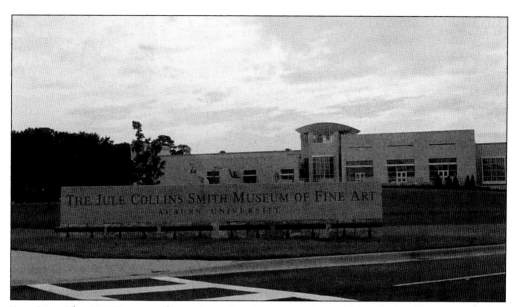

FINE ARTS. The 39,000-square-foot Jule Collins Smith Museum of Art is Alabama's sole collegiate arts museum. Accented by a three-acre lake and sculpture gardens, the museum contains eight galleries that showcase a collection of American artwork Auburn bought from the U.S. State Department and original Audubon paintings donated by Susan Phillips and her family, who are alumni and Auburn patrons. An auditorium, restaurant, and giftshop are also included in the museum.

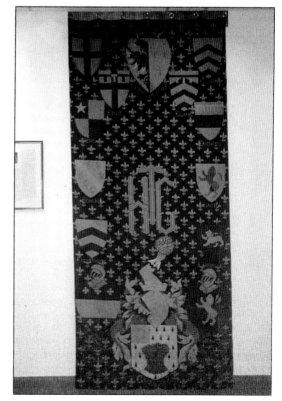

TAPESTRY. Home economics head Dana Gatchell created elaborate tapestries that are displayed on campus. This complex tapestry depicts her family's heritage and is appropriately displayed in Special Collections next to the Alabama Room, which contains genealogical resources in addition to books written by Auburn faculty and alumni and Alabama authors.

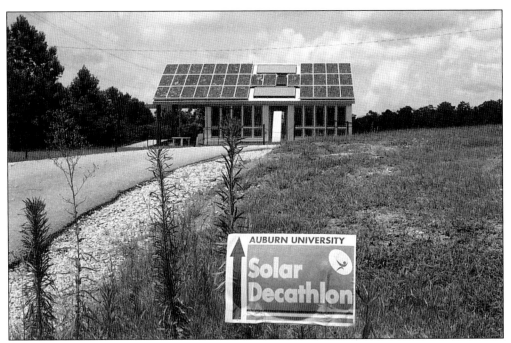

SOLAR STUDIES. Architecture and engineering students built the Auburn solar house for the first Solar Decathlon Team, a national competition sponsored by the U.S. Department of Energy to seek energy options. The house, resembling the design of a Southern dogtrot home, was displayed on the National Mall in Washington, D.C. in autumn 2002. The team lived in the home, winning first in the energy balance category and placing third overall. The house was reassembled at Auburn as a teaching tool.

VETERINARY EXPANSION. In 2003, the veterinary campus expanded with the construction of buildings in former paddocks along Wire Road. Named in honor of Dr. J.T. (Tom) Vaughn, former veterinary school dean, the buildings include the Large Animal Teaching Hospital, a lameness diagnostic arena, and barns. Cupolas and horse and cow weathervanes accent the roofs. Approximately 18,000 large animals are patients at Auburn's veterinary school yearly, and this hospital provides practical experiences for students.

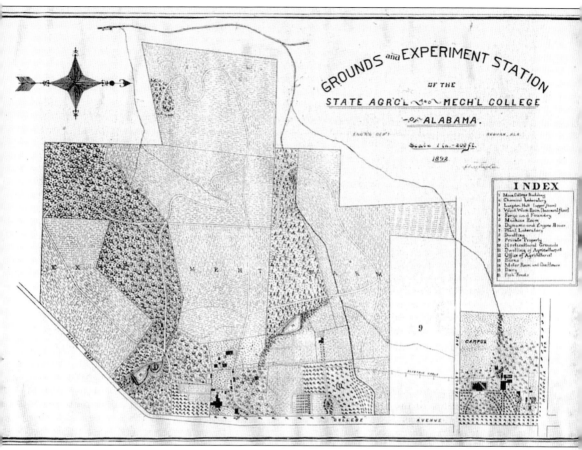

FIELDS. This 1892 map shows property around the main campus that the Alabama Agricultural Experiment Station utilized for investigations. Although some of the areas have been appropriated for buildings as Auburn has expanded, many of these fields are currently planted in crops or serve as a home to livestock being studied by Auburn researchers. Auburn agriculturists also maintain study plots in areas throughout Alabama to gain access to varying soil and plants types and climatic conditions.

LIFE SCIENCES. Named in honor of Dr. R. Dennis Rouse, the former dean of agriculture, this large building sits adjacent to Funchess Hall and the Forestry Building and is located near other buildings associated with the agricultural and science fields. The architecture of this building was designed to be compatible with other Auburn structures, such as incorporating blocks of bricks impressed with a daisy pattern like those L.A. Foster created locally for use in the 1888 construction of Samford Hall.

POULTRY. Auburn's poultry department has had many gifted researchers, including Dr. S. Allen Edgar, Dr. George Cottier, and Dr. Ethel McNeil, in its ranks. Those scientists have addressed such public health concerns as salmonella and coccidiosis. Members of the department have received national and international awards for their achievements, which have aided in making the poultry industry in Alabama and the South viable and commercially feasible. This new poultry building was constructed in 2003 across from the Old Rotation field.

Three

STUDENT LIFE

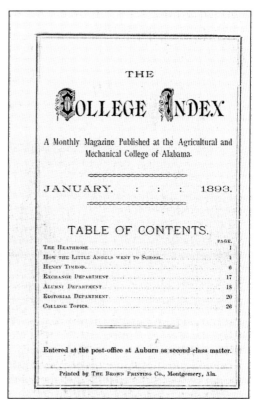

THE

COLLEGE INDEX

A Monthly Magazine Published at the Agricultural and
Mechanical College of Alabama.

JANUARY, : : : 1893.

TABLE OF CONTENTS.

Entered at the post-office at Auburn as second-class matter.

Printed by THE BROWN PRINTING CO., Montgomery, Ala.

PUBLICATIONS. Auburn students and faculty enjoyed composing fiction and nonfiction about campus life. The *College Index* was one of Auburn's first publications and included short stories featuring Auburn. Other creative periodicals from Auburn's first decades are known by name only from historical records because copies are rare or non-existent.

DEBATE. Students in the Wirt and Websterian Societies enjoyed participating in public debates. They presented attractively engraved invitations to people in the Auburn community, such as this from 1889.

COEDS. In 1892, Auburn welcomed the first official female students, who were the daughters of professors and community leaders. Records indicate that women had attended courses in previous years but had not been permitted to receive credits for degrees. Gradually, faculty daughters were joined by other young women from Alabama and Georgia in the school's classrooms. The 1901 *Glomerata* featured these Auburn sponsors of cadet and athletic teams: Misses Kate Lane, Marianne McClellan, and Olive Dent.

MUSIC. In the late 19th century, the Auburn community enjoyed attending concerts at Langdon Hall. Guest musicians were mostly men and women from the area surrounding Auburn who taught at schools in Tuskegee and other nearby communities.

Alabama Polytechnic Institute,

LANGDON HALL.

Concert

—BY—

MISS EVA M. SLATON,

MISS LELIA L. WHEELER,

MR. EDWIN L. GARDINER.

MUSIC FACULTY
OF THE
Alabama Conference Female College.

APRIL 28, AT 8 O'CLOCK, P. M.

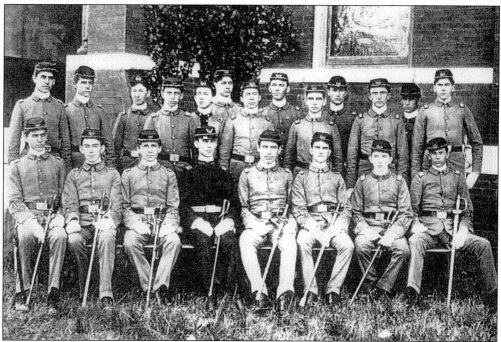

CADETS. Until the 1960s, all male Auburn students were required to participate in military training. When Auburn classes were small, group shots could easily record who was affiliated with specific military companies. Auburn's military commandant is pictured in the darker uniform, and the officers in the front row carried ceremonial swords.

INK. Students composed and edited articles about campus events for the *Orange and Blue*, a weekly newspaper. Contents included synopses of athletic events and club meetings in addition to profiles of interesting students, alumni, and faculty. Issues often contained information, puns, and inside jokes that only people at Auburn at that time would have understood. The Boyd family was prominent in early Auburn history because David French Boyd was the fifth president. Leroy Stafford Boyd later was a Library of Congress and Interstate Commerce Commission librarian.

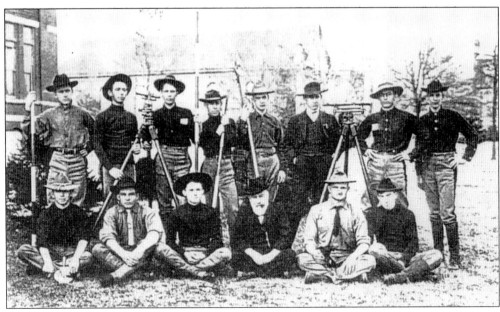

VETERAN. Gen. James H. Lane was a revered Confederate veteran from Virginia who taught civil engineering classes. Auburn students valued his professional expertise, admired his heroic past, and delighted in his sociable daughters, who were early coeds.

UNIFORMS. In the 19th and early 20th centuries, male students were required to wear military uniforms and caps such as the one pictured here. Suppliers advertised officially approved apparel in campus publications.

ATTIRE. Auburn merchants sought student customers by appealing to their school spirit to purchase clothing from stores that supplied Auburn's athletic teams.

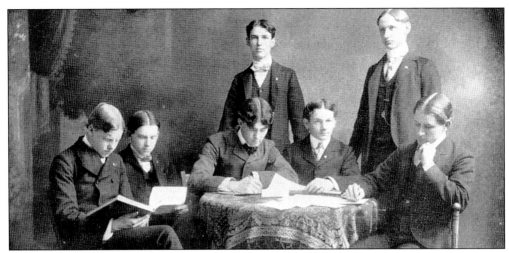

YEARBOOK. Every year, Auburn students pose for formal and informal photographs for the *Glomerata*, which is the second-largest yearbook in the United States. Published since 1897, the early *Glomerata*, the name representing a conglomeration of contents, focused so much on Greeks on campus that independents published a separate yearbook entitled *Chrysalis* in 1901. The student body elects *Glomerata* editors, and students volunteer to take photographs and write copy. This group of students served on the staff of the 1901 *Glomerata*. All seniors, they were, from left to right Shepherd H. Roberts, Kenneth Bradford, John T. Letcher (standing), editor-in-chief Robertson T. Arnold, James B. Powell, Paul S. Haley, and Matthew S. Sloan.

SENIOR HOP.
JUNE 5, 1906.

Two Step: I'm Looking For My Ten.
1. _Miss Hannon_

Waltz: I Like Your Way.
2. _Miss Weir_

Waltz: Where Broadway Meets Fifth Avenue.
3. _Dernell Borner_

Waltz: Dearie
4. _Miss Horriss_

Two Step: Just a Little Rocking Chair and You.
5. _Miss Roberts_

Waltz: On An Automobile Honeymoon.
6. _Dernell Borner_

Waltz: Lucy Linda Lady.
7. _Miss Borclay_

Two Step: Silver Heels.
8. _Miss Thach's Visitor_

Waltz: In Dreamland.
9. _-------_

Waltz: It Happened In Nordland.
10. _Otis Thach_

Waltz: A Toast To the Moon.
11. _Miss Hannon_

Two Step: Keep a Little Cozy Corner In Your Heart For Me.
12. _Miss Hield_

Waltz: Golden Sunset.
13. _Miss Hord_

Waltz: Sympathy.
14. _-------_

Two Step: St. Louis Tickle.
15. _-------_

Waltz: The Prince of Pilsen.
16. _Miss Wheeler_

Waltz: Come Take a Trip In My Air Ship.
17. _Miss Thach's Visitor_

Waltz: Because You Were An Old Sweetheart Of Mine.
18. _Miss O. Thach_

Two Step: Don't Be What You Ain't.
19. _Miss Julia Frazer_

Waltz: Remembrance of Paw Paw.
20. _Miss Borclay_

Waltz: Goodbye Sweetheart, Goodbye.
21. _Miss Hord_

Two Step: Sergeant Kitty.
22. _Miss Wheeler_

Waltz: Miss Dolly Dollars
23. _Miss Hannon_

Waltz: Peggy Brady.
24. _Miss Roberts_

Waltz: Friends That Are Good and True.

DANCE. Nimrod D. Denson Jr. kept this dance card that identified his dancing partners at the senior hop. The music and steps may have changed over the years, but Auburn students of every generation have enjoyed dances, ranging from formals with orchestras to sock hops gyrating to radio broadcasts.

42

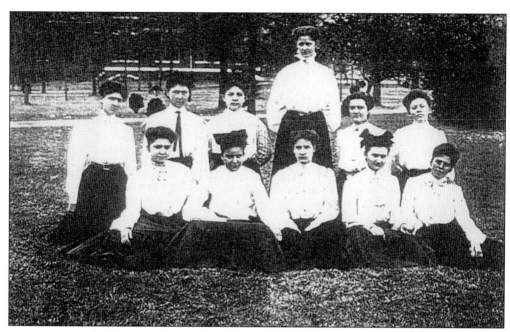

WOMEN. By the 1910s and 1920s, more coeds enrolled at Auburn, including both unmarried women and wives of local men. Student pictures are clarified with courtesy titles of Miss and Mrs. in *Glomeratas*. Most female students studied liberal arts and education, although a few like Dorothy Duggar and Evans Harrell took agricultural or architecture courses.

GLOBAL STUDENTS. The first foreign students who enrolled at Auburn arrived from Mexico, the Caribbean, and Central and South America in the late 19th century. Since then, students from Europe, Asia, Africa, and the Middle East have also traveled to Auburn to study in classrooms, to research in laboratories, and/or to compete in athletics. Shu Min Wong '17 from Shanghai, China, had been a colonel in the Chinese army before he came to Auburn to study agronomy. He participated in clubs, was an officer in the Websterian Society and YMCA, and won declamation and oratorical medals. No further information is available about why he came to Auburn or his fate after graduation.

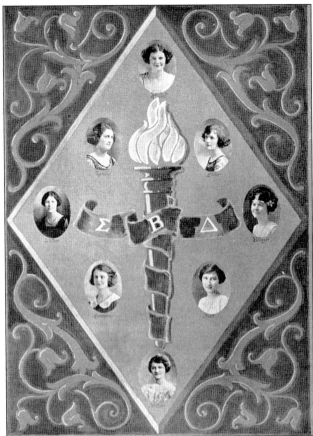

SISTERHOOD. Greek sororities first appeared at Auburn in the 1920s. Most chapters established at Auburn represented national sororities such as Kappa Delta and Alpha Gamma Delta. Several were unique to Auburn. Sigma Beta Delta sorority was founded at Auburn in 1922 and only remained on campus for a short time. Several Short-lived fraternities were also established exclusively on campus.

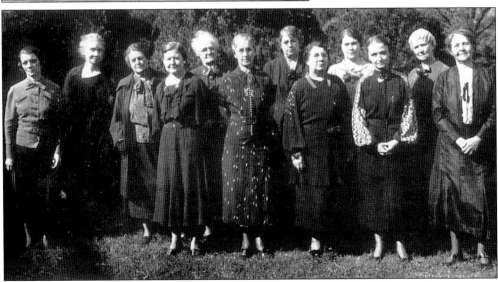

MATERNAL. Housemothers lived in each fraternity house to advise and monitor the members while overseeing their domestic needs. Many of Auburn's housemothers were widows who welcomed the chance to earn money in a position that earned them respect from the Auburn community. Some used their salaries to pay for their children's college education.

DRAMA. Auburn students enjoy watching or performing theater. *The Wonder Hat* was a favorite play in 1920 presented by the Auburn Players. Male students played all the roles, even the main character, Margot.

MANNERS. The Cotillion Club was a popular group in which Auburn students could practice etiquette and graces they might encounter in professional and social situations after they graduated from college. Members delighted in dressing up and indulging in dancing parties in winter. Male students appreciated that "Grand, glorious, graceful girls came to us from every section of the Southland." Orchestras also arrived, and "the dancing coterie of Auburn crowded the gymnasium from morn' `till night."

CURFEW. Female students at Auburn faced strict regulations until administrators began easing rules in the 1960s. Rules monitored where coeds could live, what they could wear, how they could behave, what hours they were required to stay in dormitories, and when they could leave campus. Coeds were required to alert staff to their whereabouts at all times and had to secure permission to leave campus. Cards were provided for each coed to write when and where they were going when they were not on campus. This coed is signing out of her dorm in 1947.

NEWS. The *Orange and Blue* was renamed *The Plainsman* in the 1920s. Both male and female students performed various duties to investigate leads, write copy, interview and photograph subjects, edit text, sell advertising, and other skills to prepare them for journalism and publishing careers. The paper strived to be more professional than its predecessor.

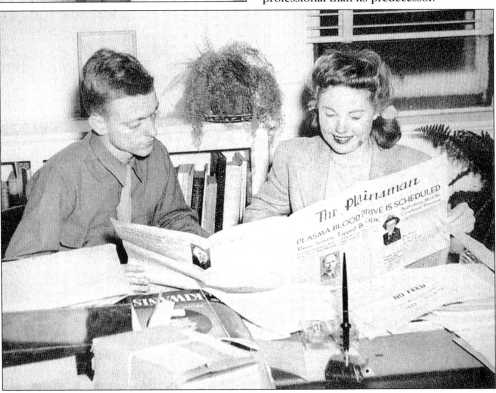

PUBLICATIONS. Auburn veterinary students began publishing *The Auburn Veterinarian* in 1945. Published until 1989, the magazine printed photographs of veterinary faculty, staff, and students in addition to news about Auburn veterinarians and articles about current veterinary diagnostic techniques and findings. Dr. Wilford Bailey, who served as Auburn's 13th president, maintained copies of this magazine to chronicle the profession's history at Auburn. The copy pictured here was in his personal collection.

The
AUBURN VETERINARIAN

In This Issue

Volume I WINTER 1945 Number 1

Publication of the A. P. I. Student Chapter of American Veterinary
Medical Association

R.S.V.P. Students did not mind standing in line to order graduation invitations. These 1951 graduates eagerly purchased engraved cards and envelopes to send to family and friends.

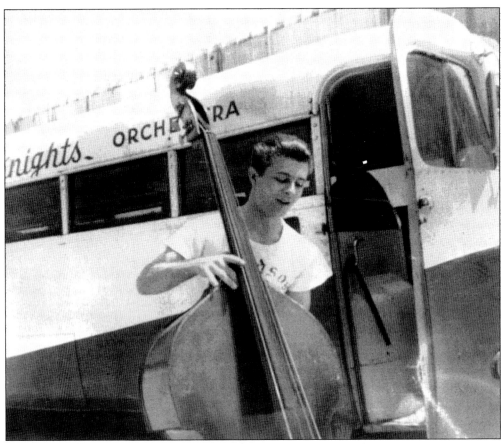

AUBURN KNIGHTS. Bob Richardson loads his instrument on the Auburn Knights Orchestra's bus. He was an alumnus and faculty member whose skills as a jazz pianist won accolades across campus and invitations to play for parties at Auburn's president's mansion. The Auburn Knights Orchestra was created in 1928 initially as The Auburn Collegians, and for generations members have delighted the Auburn community with big band and jazz music. The Auburn Knights often played for campus dances at Auburn as well as at other schools.

ANTICIPATION. Before registration and changing schedules became available by phone and the Internet in the late 20th century, Auburn students often spent so much time standing in line that they should have gotten credits for their efforts.

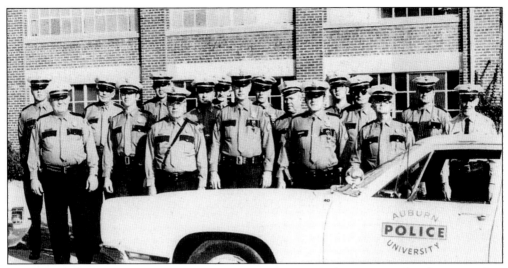

PARKING. For decades, Auburn students have been at odds with the campus police force regarding parking. As the student population expanded, so did the number of vehicles. All cars are required to be registered to park on campus, but there usually are more vehicles registered than parking spaces available. Some students try to fight tickets in traffic court, but most are unsuccessful. All fines must be paid before students can graduate. Alternate transportation methods have been implemented, including hourly Tiger Transit shuttle buses between campus and off-campus housing to primary classroom sites.

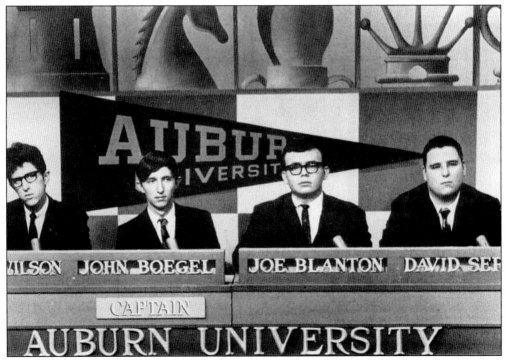

COLLEGE BOWL. Members of Auburn's debate team competed against Oklahoma students on the nationally televised GE College Bowl in the late 1960s.

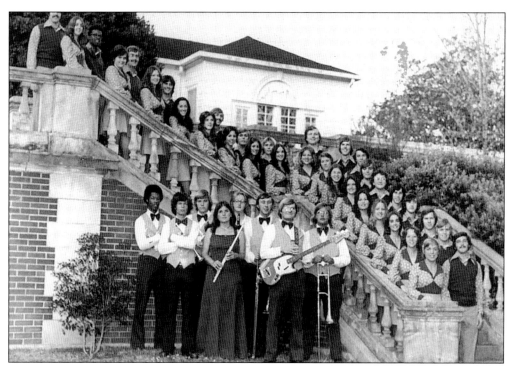

SINGERS. The Auburn University Singers have represented Auburn worldwide and have appeared on television with such notables as Katie Couric. Competition to become a singer is intense, and traveling and performing can be grueling yet fulfilling. This is the first group of singers in 1974–1975 behind Cater Hall.

ORCHESTRA. The Auburn Orchestra includes student, staff, and faculty musicians. This ensemble, including Dr. Richard Amacher to the right, is rehearsing in the 1990s under the direction of Dr. Howard Goldstein.

ENTERTAINMENT. Campus organizations have arranged for astounding entertainment on campus. Auburn students have enjoyed performances by national and international celebrities. Elvis Presley, Tina Turner, Pat Benatar, Olivia Newton-John, Chicago, the Beach Boys, and other musical sensations have played at Auburn. Classical pianist Van Cliburn performed as well as touring in stage groups such as this cast of *The Wiz*, which delighted a standing-room-only crowd in January 1979.

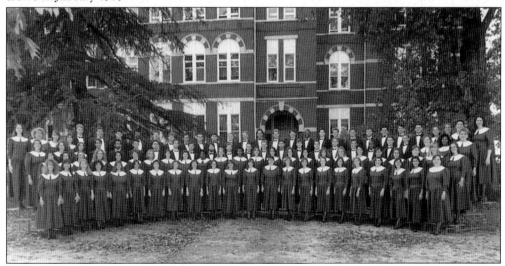

CONCERT CHOIR. Music is an important dynamic of Auburn culture. Members of Auburn's Concert Choir, like many campus groups, pose for their formal photograph in front of Samford Hall. Representing Auburn, these singers toured Europe. Students and the music department have established other singing groups to accommodate musical interests such as the Gospel Choir.

51

LAKEWOOD COMMONS. Student housing is an important concern at Auburn. While many students choose to live in dormitories or fraternity houses, many elect to live in apartments and trailers. The construction of condominiums named Lakewood Commons in the early 1980s ushered in a new lifestyle for students and an investment opportunity for parents. Within years, students had additional condo options at Crossland Downs and The Brookes. By the early 21st century, some condos offer such luxuries as media centers, theaters, gymnasiums, and tanning beds.

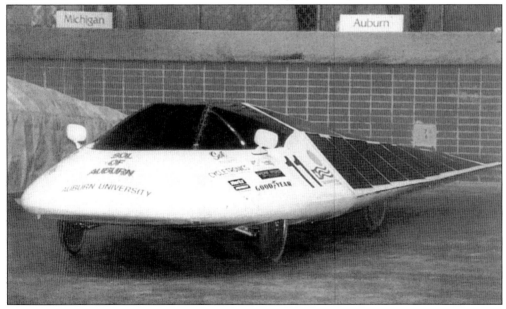

SOL. Pictured here is the original late 1980s solar car that Auburn students built and raced in a cross-country competition sponsored by the U.S. Department of Energy for collegians. Annually, an Auburn team, usually consisting of engineering students, improves designs and strategies to maneuver a solar car across more than 2,000 miles of highway. Each Auburn vehicle has been powered by batteries that collect solar energy from panels mounted on the car to fuel it. Although Auburn has yet to win a race, they have performed admirably.

FOREIGN STUDIES. Since 2002, Auburn's College of Human Sciences has sponsored a summer semester study program at Auburn's sole overseas campus, located at the 17th-century baroque museum Palazzo Chigi in Ariccia, Italy, near Rome. Auburn students and faculty immerse themselves in a foreign culture while gaining awareness of subjects in their academic fields to improve life quality. The 16 credit hours qualify for an International Minor in Human Sciences. Human sciences dean June Henton aspires to make this program available all semesters. For decades, many Auburn students enrolled in international study programs around the world. Susan Karamanian '79 was a Rhodes Scholar who supplemented her Auburn education with an Oxford University master's degree.

WORK/STUDY. Many students work during their years at Auburn. Jobs are available on campus in dining halls, the library, departments, the veterinary school, and other sites. Students also have opportunities to co-op and alternate sessions of coursework with employment and internships, which prepare them for post-graduation careers. Some off-campus businesses hire students and celebrate their achievements as evidenced by this sign. The business pictured here indicates the importance of pets to many students at Auburn.

LICENSE TO LEARN. Auburn fans often invest in Auburn University license plates to generate revenue for scholarships. Auburn has consistently led all universities in Alabama for the number of higher education tags registered. Virginia and Tennessee have also issued special plates with the Auburn logo. Drivers often personalize their tags with variations of letters that incorporate references to the words "Tiger" and "War Eagle." During football season, many fans display fake tiger tails hanging from the rear of their vehicles in addition to bumper stickers, orange and blue shakers, stuffed tigers adhered to windows with suction cups, pennants, and other Auburn paraphernalia.

J&M. Since 1953, many Auburn students have bought required textbooks at Johnston and Malone Bookstore (http://www.jmbooks.com). Located adjacent to Toomer's Corner on College Street, J&M is Auburn's oldest existing bookstore. The Johnston family has deep ties with Auburn with several generations of prominent alumni and athletes belonging to that family. J&M has operated bookstores on other Southern college campuses and managed the giftshop at the university's hotel and conference center. This eagle, commemorating store founder George Johnston, is displayed in front of the new J&M store at Auburn's University Village.

Four

NOTABLE PEOPLE ON CAMPUS

BOTANISTS. Auburn professor George F. Atkinson held the first chair of biology in the South. In 1966, Auburn named a tomato variety Atkinson. Atkinson's assistant, Benjamin Minge Duggar, was the brother of experiment station and extension services director John F. Duggar. Benjamin Duggar began his fungi investigations with Atkinson at Auburn, earning a master's degree. He gained international attention when he discovered aureomycin to treat Q fever and Rocky Mountain spotted fever. Duggar was selected for membership in the prestigious National Academy of Sciences.

NOBEL ORIGINS. As this page from the 1917 catalogue indicates, William Jacobs Robbins taught botany at API from 1916 to 1917 when he left Auburn to care for his dying father-in-law in Massachusetts. During his year at Auburn, Robbins initiated notable plant physiology research that he continued pursuing during later appointments at the University of Missouri and as director of the New York Botanical Gardens. He and his wife, Christine Chapman Robbins, who was also a botanist, enjoyed the Auburn community. Their son, Frederick Chapman Robbins, was born in Auburn and won a Nobel Prize for polio research in 1954. Reference books and media refer to Auburn as his hometown.

MEMORIALS AT SEA. Walter Lynwood Fleming earned a bachelor's degree from Auburn in 1896 and a master's degree in 1897. He became a renowned historian, publishing such classic works as *Civil War and Reconstruction in Alabama* (1905). His achievements earned Fleming's inclusion in the Alabama Hall of Fame. Fleming married Mary Boyd, the daughter of David French Boyd, Auburn's fifth president. After Fleming's death, his widow christened World War II Liberty Ship 1542 named in his honor. Another Liberty Ship was named in honor of Cassius Hudson, an Auburn alumnus who was the first county agent and state farm demonstration agent in North Carolina.

TEXTILE PIONEER. Auburn alumnus and professor Edmond Weymon Camp was a textile engineering pioneer. In November 1901, he became the first textile engineering graduate in the Western Hemisphere when he graduated from Georgia Tech. Camp managed textile mills in Georgia, taught at Georgia Tech, and became the first faculty member hired at Texas Tech University, where he established the textile engineering department. Camp accepted a position at Auburn, where he earned a master's degree in chemical engineering, working with chemist Dr. Clement Basore. Camp also created Auburn's textile engineering department.

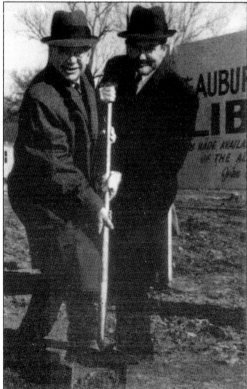

BOOKS. Pres. Ralph B. Draughon and Gov. John Patterson are jubilant at the groundbreaking for the Draughon Library in the early 1960s. A larger library was necessary to replace the smaller Martin Hall, where librarians sometimes gave books away to ease shelf space.

MISS CAROLINE. One of Auburn's most-beloved first ladies, Caroline Marshall Draughon had an impact with faculty, staff, students, and their families. She sponsored the Dames Club—the predecessor to the Campus Club—to provide activities for women on campus. In this photograph, she is assisting the Easter Bunny to help children find Easter eggs during the annual hunt on the president's lawn.

BOARD OF TRUSTEES. Members of the board of trustees posed on campus in 1952. Pictured, from left to right, are (front) E.A. Roberts, Redus Collier, Paul S. Haley, and Berta Dunn (secretary); (back) Walker Reynolds, Frank P. Samford, Ralph B. Draughon, Jimmy Hitchcock, Vernon S. Summerlin, W.L. Parrish, and G.H. Wright Sr.

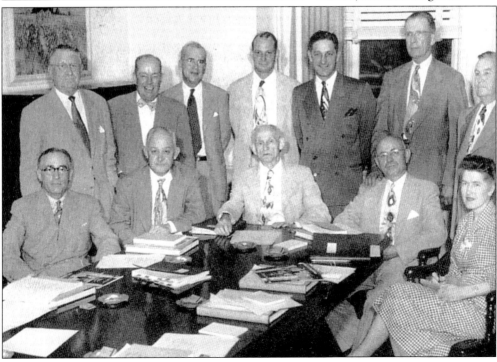

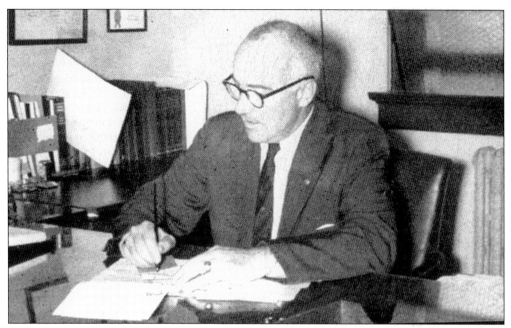

PROFESSIONALISM. Veterinary dean James E. Greene helped establish small animal medicine as a professional field. Serving as head of Auburn's Department of Small Animal Surgery and Medicine, he was promoted to be the veterinary college's fourth dean after Dean Redding S. Sugg died in 1958. Greene was active in the American Veterinary Medical Association (AVMA) to standardize educational standards for the professionalization of veterinary medicine. He received the AVMA Award, the association's most prestigious prize in 1975. Three years later, Auburn renamed the Basic Sciences Building for Greene to recognize his achievements to the veterinary field and to Auburn—increasing enrollment by approximately 45 percent with faculty and staff "growing fourfold."

TV. Lee Cannon hosted a televised program called *Today's Home* for Auburn's School of Home Economics from the 1950s through 1970s. The program was filmed in a campus television studio. Cannon is pictured during a show that aired in 1965. Her guests included such notables as Bob Hope and Ralph Nader.

AQUACULTURE. Homer S. Swingle established and guided Auburn's fisheries department for decades. Students travel from distant countries to benefit from fisheries research and lessons at Auburn. Swingle is pictured between Abdul Raham Khan Zobairi of Pakistan and Jinda Thiemmedh of Thailand. Because of the fisheries department, Auburn alumni can be found in such exotic places as Bangladesh and Nigeria.

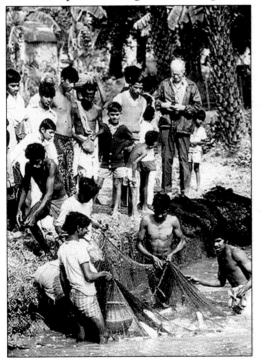

TECHNOLOGY TRANSFER. Professors often traveled to faraway places to help people by sharing information gained in Auburn's laboratories. Fisheries professor Jack Snow is shown here in India. Auburn researchers have genetically created fish with high protein levels that require minimal care and predictably produce large yields. These fish help nations establish commercial fisheries where traditional food supplies are diminishing while populations are expanding rapidly.

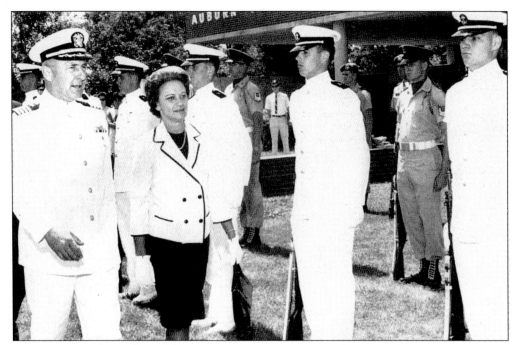

ATTENTION! Traditionally, Alabama's governor reviews Auburn's military students and commandants. Every spring, Auburn cadets assemble for review. Prominent military and political leaders usually attend reviews. On Governor's Day in 1967, Gov. Lurleen Wallace marches past Auburn ROTC cadets with their commandant. Wallace was the first female chairman of Auburn's board of trustees.

GOVERNOR. Auburn president Harry Philpot and professor Dennis Rouse present Gov. George Wallace a medal commemorating the centennial of the agricultural experiment station. As chairman of the board of trustees, Alabama's governor has significant input in how Auburn is governed and operates. Wallace visited Auburn many times.

TIGER BY THE TAIL. Deans James E. Foy V and Katharine C. Cater playfully pose with Auburn's mascot. The student union is named in honor of Foy, who served as dean of student affairs from 1950 to 1978. Across Thach Street, Cater Hall is named in honor of the longtime dean of women and social director, then dean of student life. The Alabama Women's Hall of Fame inducted Cater in 1988 (Auburn Home Economics dean, Marion Walker Spidle, also received that honor). The Cater Society yearly recognizes 15 students who exhibited leadership for women's education at Auburn. The ODK-James E. Foy V Sportsmanship Trophy is presented annually to the winner of the Iron Bowl during halftime on the winner's home court at the Auburn-Alabama basketball game.

THANKS FOR THE MEMORIES. Bob Hope entertained on campus twice in the 1970s. He is pictured here at a 1970 football game with Gov. Albert Brewer and Auburn's 11th president, Harry Philpott.

RENAISSANCE MAN. Dr. Wilford S. Bailey, Auburn's 13th president, devoted his career to Auburn. His widowed mother ran a boarding house to support her son's educational aspirations. He earned a DVM in 1942, then earned a master's at Auburn, and completed a doctorate at Johns Hopkins University. He filled many positions at Auburn, including head of the Department of Pathology and Parasitology and associate dean of the Graduate School. In 1984, Bailey was named the first university professor after he completed his presidency. Bailey traveled to foreign countries to share his research. He received Auburn's prestigious Algernon Sydney Sullivan Award in 1986.

ART. Professors Maltby Sykes and Taylor Littleton '51, whose many significant administrative positions and titles at Auburn included Mosley Professor of Science and Humanities, wrote *Advancing American Art*. This book discusses paintings the U.S. State Department assembled for a post–World War II exhibit. When protests stopped that exhibit, Auburn art professors decided to forego raises so that Auburn could use that money to purchase 36 paintings. Those paintings are displayed at Auburn's art museum.

VACCINES. Dr. S. Allen Edgar was a pioneer researching poultry diseases and developing vaccines. His first vaccines tackled coccidiosis and infectious bursal disease virus. He discovered and named a coccidian species in chickens. Edgar was a mentor to graduate students as well as a consultant to companies that produced drugs combating coccidia. He was inducted into the Alabama Poultry Industry Hall of Fame and named Workhorse of the Year for the U.S. Poultry and Egg Association.

PROBLEM SOLVER. In 1994, Dr. Krystyna Kuperberg, Alumni Professor of Mathematics, solved the "Seifert Conjecture" regarding topology of dynamical systems. The problem had remained unsolved since 1950. The *New Scientist* declared that "her proof involves a brilliant new idea, destined to change the face of higher dimensional dynamics." The *Annals of Mathematics* and the *Encyclopedia Britannica* yearbook noted her achievement. Kuperberg, who is in demand nationally and internationally as a speaker, credits her persistence in solving the problem.

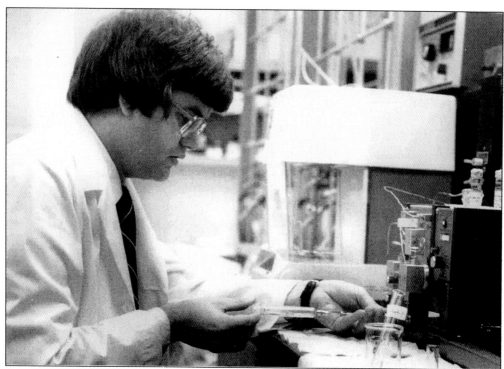

PHARMACY. Dr. Randall Clark specializes in medicinal pharmacy in the Department of Pharmacal Sciences. His experiments have flown aboard the space shuttle so that Clark can investigate how zero gravity affects medicines. Clark has served as graduation marshal for pharmacy ceremonies, hooding newly degreed pharmacists. Auburn pharmacists have shaped the profession in Alabama and nationally. Paul Molyneux '13 was the first Auburn alumnus appointed to the Alabama State Board of Pharmacy and selected as president of the National Association of Boards of Pharmacy.

INNOVATOR. Dr. Rodrigo Rodriguez-Kabana, on the right, is pictured with Dr. Gareth Morgan-Jones. A Distinguished University Professor in the Department of Entomology and Plant Pathology, Rodriguez has patented much of the results from his Auburn research. He developed an environmentally non-hazardous pesticide as an alternative to banned chemicals. His SEP-100 liquid formulation of sodium azide for drip irrigation systems improves soil and does not kill beneficial insects and nematodes. Auburn will earn royalties when Rodriguez's invention is commercially sold.

RURAL STUDIO. Drs. D.K. Ruth, Paul Parks, David Wilson, and Samuel Mockbee '74 pose in front of Auburn Architecture's Rural Studio. Auburn architects have appropriated materials such as hay bales, tires, and license plates to build homes for impoverished residents of rural Alabama. Mockbee stated, "Architecture should be about giving people places to live, instead of creating monuments to yourself."

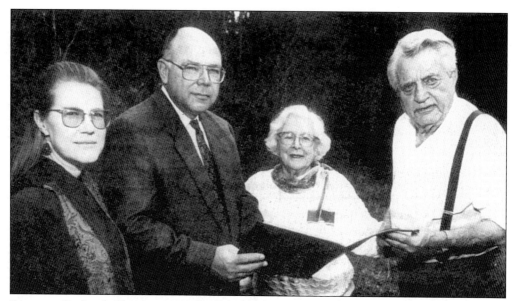

FORESTRY. Dr. Louise Turner, a retired Auburn physical education professor who had trained with the legendary dancer Martha Graham in New York and her husband, Frank Turner, gave the AU Foundation 110 acres of Piedmont forest near campus to use for forestry and environmental research, education, and outreach. Auburn faculty, staff, and students and the public benefit from the Louise Kerher Forest Ecology Preserve. Louise and Frank Turner are pictured at the right with forestry dean Emmett F. Thompson and professor Kathryn Flynn.

CAMPUS CLUB. Auburn first ladies Marlene Muse and Caroline Draughon and Campus Club president Carolyn Schafer are pictured in 1994. Draughon created the Campus Club after World War II when enrollment increased and faculty wives needed activities. Currently, spouses, women faculty and staff, and anyone interested can participate in Campus Club projects. The Campus Club raises funds for scholarships in honor of Draughon and other Auburn first ladies.

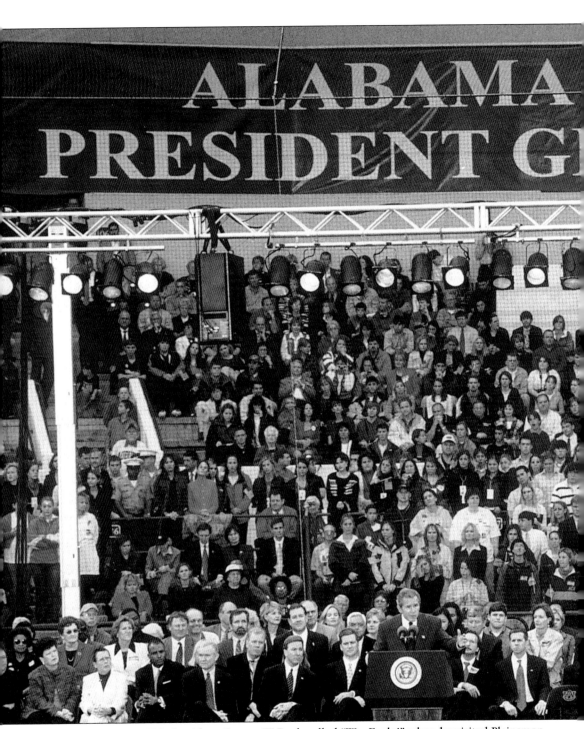

PRESIDENTIAL VISIT. U.S. President George W. Bush yelled "War Eagle!" when he visited Plainsman Park on October 24, 2002, to campaign for Republican candidates. In 1939, President Franklin D. Roosevelt toured Auburn's campus. Eleanor Roosevelt also visited Auburn. Confederate

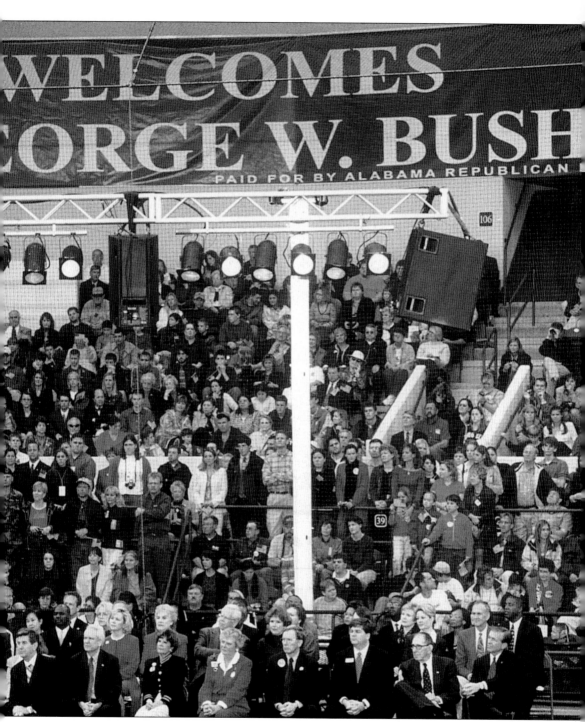

President Jefferson Davis reviewed Auburn's cadet corps during the Civil War. Former President Theodore Roosevelt was in the area when he attended a rally in Opelika while campaigning in 1912.

TECHNOLOGY HISTORY. Auburn blends the sciences and liberal arts and has become an internationally acclaimed center of aerospace history. At the far right is pictured Distinguished Professor of History Dr. W. David Lewis, who initiated Auburn's "Tech and Civ" freshman history courses for engineering and science majors. He has earned many honors, including being Charles A. Lindbergh Professor of Aerospace History at the Smithsonian Air and Space Museum. To the far left is pictured former History Department Head Dr. James R. Hansen, who was the first person to have a NASA history nominated for a Pulitzer Prize and the only person authorized to write a biography of moon pioneer Neil Armstrong. They are pictured with the first graduates, Timothy Mahaney and Elizabeth D. Schafer, of the Ph.D. program in technology history.

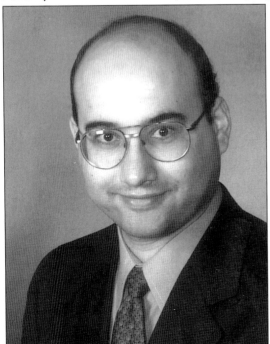

CLASS ACT. Alumni Prof. Dr. Mahmoud El-Halwagi is a chemical engineer who received the National Science Foundation's National Young Investigator Award in 1994. At Auburn, he has been selected as engineering's outstanding faculty member multiple times, in addition to students in SGA, Panhellenic, and Mortar Board also naming him an outstanding teacher. El-Halwagi also won the Fred H. Pumphrey Teaching Award in 1997 and the Birdsong Merit Teaching Award, Auburn's highest teaching honor. He perceives teaching and research as symbiotic and emphasizes teaching students how to think and adjust to changing technology to solve problems and innovate.

Five

INTERESTING STUDENTS AND ALUMNI

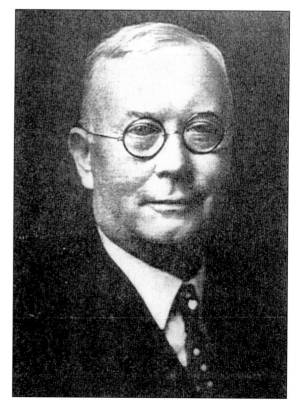

INVENTOR. Joseph A. Williams, Class of 1891, gained fame and fortune by inventing the ignition system that Henry Ford chose to install in Model T Ford automobiles. A native of Jefferson County, he innovated telephonic devices after he left Auburn and then founded the K.W. Kgnition Co. in Cleveland, Ohio. Williams traveled to Detroit to meet Ford and convinced him to buy his ignitions. Earning millions, Williams generously donated monies to Auburn.

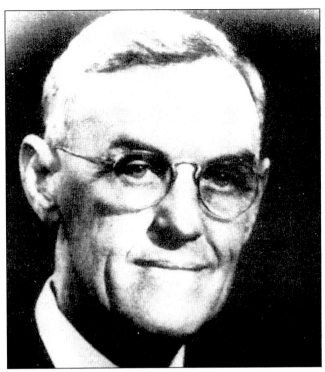

STATISTICIAN. George Waddell Snedecor '02 was a campus leader who was an officer in the YMCA and helped establish Auburn's chapter of Kappa Sigma. He studied electrical engineering and agriculture. Teaching at Iowa State College, Snedecor became a pioneer in statistics, applying methods to agriculture. His statistics textbook, *Statistical Methods*, became a classic that is still used today. A building on the Iowa State campus is named for him. Snedecor retained his ties with Auburn, returning to campus for professional presentations and collaboration, including spending the winter quarter of 1954 at Auburn.

ARCHITECT. Evans Harrell was the first woman to earn an architecture degree from Auburn. She aspired to design buildings, but, at that time, women encountered obstacles to achieving professional architectural careers. Harrell returned to school for a master's degree and then taught business courses.

TWIST OF FATE. Walter Wier Johnston '04 of Anniston completed a bachelor's degree in civil engineering and worked in that field before returning to his alma mater for graduate work. Working in Spain when he completed his thesis, he mailed the document to the Auburn faculty. Unfortunately, his thesis was placed in a mailbag that was shipped on the *Titanic*. The Auburn Board of Trustees discussed Johnston's situation and decided to grant him a degree. A decade later, Johnston encountered another disaster when the ship on which he was traveling was near Japan during an earthquake. Johnston and a colleague photographed and documented that calamity in "Report on Earthquake and Fire Which Occurred in the Vicinity of Yokohama and Tokyo, September 1, 1923."

HISTORIANS. The Owsley and Moore brothers (left to right, Frank and Clark Owsley and J.M. and A.B. Moore) were friends at Auburn and throughout their careers. Frank L. Owsley '11 and Albert B. Moore '11 became nationally known Southern historians. Owsley became one of the famed Agrarians at Vanderbilt, contributing to the classic *I'll Take My Stand*. He received a Guggenheim Fellowship to research documents relevant to his book-in-progress *King Cotton Diplomacy* in European archives. He received numerous honors and was a Fulbright Lecturer at Cambridge University when he died. Owsley's son, Frank L. Owsley Jr., taught in the Auburn history department.

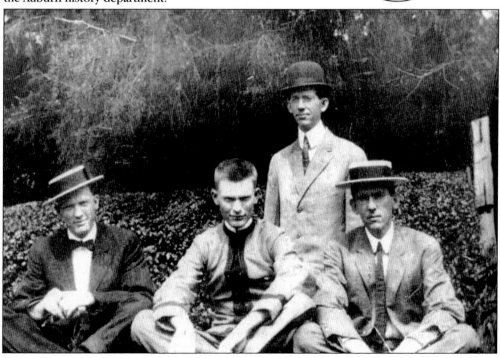

AIR CONDITIONING. Otis William Bynum '30, an Auburn electrical engineering alumnus, was president and CEO of Carrier Corporation in Syracuse, New York. He retuned to Auburn when he retired and lived in what is now the Crenshaw House. Bynum was inducted into the Alabama Engineering Hall of Fame for pioneering development and production of air control equipment for homes and businesses.

CORRESPONDENT. Edward D. Ball '26 from Selma was a reporter and editor-in-chief for *The Plainsman* at Auburn. During World War II, he was a war correspondent for the Associated Press in Europe, moving with troops as they liberated Nazi-held areas. Ball was the first American newsman to cross the Rhine River with Gen. George Patton's troops. His post-war career included serving as editor of *The Nashville Tennessean*.

TELEPHONE. Ben S. Gilmer '26 was the business manager of the *Glomerata* and enjoyed the Cotillion Club at Auburn. The yearbook described him as "a conscientious student and above all a gentleman" but humorously said to "Blame the errors of the 'Glomerata' on him." Gilmer's noteworthy career included the presidency of Southern Bell and AT&T.

(Above left) PANAMA. Hugh M. Arnold '31, a civil engineering student from Newnan, Georgia, later became the lieutenant governor of the Canal Zone. Many Auburn military alumni had some role in building and maintaining the Panama Canal.

(Above right) HYDRAULIC ENGINEER. Roger B. McWhorter '09 oversaw many hydraulic engineering projects, including flood control in Georgia that he wanted Auburn students to observe. He supervised construction of Wilson Dam in northern Alabama, which at that time was the largest hydroelectric development in the world. He was chief engineer of the Federal Power Commission and was a member of the International Joint Commission to improve deep-draft navigation of the St. Lawrence River. He won the admiration of his colleagues as evidenced by this letter from President Dwight D. Eisenhower. In 1947, McWhorter declared, "no man who has ever left the halls of Auburn loves the old place more than does Roger McWhorter."

CEO. Frank Richard Deakins '14 of Sequatchie, Tennessee, was "one of the most popular men in the college" and earned an electrical engineering degree. During World War II, he was president of RCA Victor Co., Ltd., in Canada and focused on production to fulfill Canadian governmental war needs. He also was the executive assistant for the general manager of RCA Victor U.S.

STATE DOCKS. Charles Edward Sauls '12, a civil engineering major from Columbus, Georgia, was director of the Alabama State Docks and terminals in Mobile. At Auburn, he was involved in many club activities and held such positions as senior class president and yearbook editor. The *Glomerata* praised his loyalty to his class and Auburn, predicting his engineering prowess "will doubtless reflect honor on his native state as well as Alabama." Sauls served as an engineer in World War I.

POWER. Clifford B. McManus '16 was president of Georgia Power Company and the Southern Company. As a teenager in Smithville, Georgia, he installed electrical systems in his community. He worked at the Atlanta Electric Machine Company before studying electrical engineering at Auburn. Plant McManus was named for him near Brunswick, Georgia. His classmate Lonnie Sweatt '15 was president of the Mississippi Power Company and had operated Auburn's campus power system. Many of their power company colleagues were Auburn men.

GOVERNOR. Seth Gordon Persons '22 served as Alabama's 46th governor from 1951 to 1955. An electrical engineering student from Montgomery, he expanded radio station WSFA after graduation and was chairman of the Alabama Rural Electrification Authority and member of the Public Service Commission. Person's first gubernatorial action was naming Ralph "Shug" Jordan as football coach. Persons and his family were the first to live in the current governor's mansion. Alumni Forrest H. "Fob" James Jr. '57 also was elected Alabama governor in 1978 and William James Samford was governor in 1900–1901.

ELECTRIFYING. Maria Rogan Whitson '23 of Talladega had graduated from Virginia's Randolph-Macon Woman's College when she enrolled at Auburn to study engineering. The *Glomerata* stated that "Maria is the only girl that has completed a course in Electrical Engineering at Auburn. She is a conscientious student. A mighty good sport." Active in the electrical engineering association, women's student government, and YWCA, Whitson had a post-graduate career with the Alabama Power Company.

STREET. Jabez Curry Street '27 was the grandson of Auburn's first Greek and Latin professor John Dunklin. An electrical engineering student and student instructor in that subject and physics, he prepared for a career as a high-energy physicist. Street gained international attention when he identified a new particle that physicists call the muon. He was selected for membership in the National Academy of Sciences for his cosmic ray research.

METRO. Roy Tinsley Dodge '38 was a student leader at Auburn and a World War II veteran who became a brigadier general in the Army Corps of Engineers. He was selected to serve as general manager of the Washington Metropolitan Area Transit Authority in the 1960s and 1970s. As design and construction chief of the Washington, D.C. metro subway system, the largest public works project in the United States at that time, he influenced many basic components such as colors used for car interiors. His sense of integrity prevented corrupt people from taking advantage of contracts and other elements of the Metro's construction.

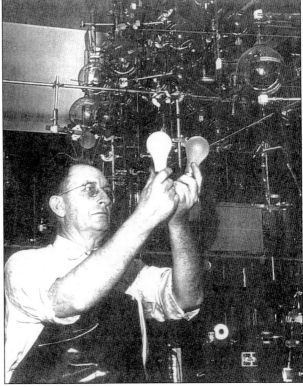

ILLUMINATION. Marvin Pipkin '13 of Mulberry, Florida, majored in chemistry and metallurgy. The *Glomerata* expressed the student body's pride in Pipkin for his intelligence and ability, reporting he "was never known to use professor Williamson's methods in the laboratory, as he always used his own which were just as good." He spent his professional career innovating devices, particularly electric lamps to improve light diffusion, for General Electric. Pipkin is pictured with his inventions: the inside frosted lamp and white inside finish light bulb. He also invented a charcoal filter for World War I gas masks and improved the photo flash bulb.

(Above left) **FAMILY.** Caroline Lawson Ivey '34 grew up in Smiths near Auburn. Her novel, *The Family*, which focuses on a rural Alabama family and the newlywed daughter's Northern husband's reactions to Southern culture, mentions Auburn. When her novel was published in 1952, it was received well by critics. One reviewer wrote, "The author is perceptive. And she can write." Ivey's husband was Auburn history professor Oliver Turner Ivey.

(Above right) **INVESTIGATOR.** June Krause Jones '39, a chemistry major from Fort Lauderdale, Florida, had an outstanding career as a toxicologist. She was the chief toxicologist of the Georgia State Crime Laboratory and received many significant awards, including the prestigious Laboratory World Achievement Award and being named Distinguished Fellow of Forensic Science for her scientific contributions to that investigative field. Jones served as president of the American Academy of Forensic Sciences.

WOMAN VETERINARIAN. Dr. Lucille Dimmerling '43 was the first woman to graduate from Auburn's veterinary school. She and her husband, Derwin S. Dimmerling '42, who also earned an Auburn DVM, owned a veterinary hospital in his hometown, East Liverpool, Ohio. Dimmerling served as the first president of the Women's Veterinary Medical Association (renamed the Association for Women Veterinarians in 1980) when it was organized in 1947. The American Veterinary Medical Association chose her to broadcast radio announcements on its behalf because she was the "typical woman veterinarian."

LEGACY. Several generations of Opelika's Turnham family are Auburn alumni. Former State Representative Pete Turnham '44 and M.S. '48, pictured here on campus in the early 1940s, was the longest-serving member of the state legislature when he retired. Known as the "Dean of the Alabama Legislature," he won 20 elections from 1958 to 1998 to represent House District 79. He promoted education. Auburn president William V. Muse awarded Turnham the Legislative Tiger Award on behalf of the Auburn Legislative Action Network to honor legislators "exemplifying dedication to and support of Auburn University and its legislative efforts." Muse stated, "Pete Turnham sets the standard for devotion to and support of Auburn University." Turnham remarked, "I put my whole heart into it."

FIRSTS. When male students enlisted for military service in World War II, many positions on campus became more accessible to women. In 1943, "Tutter" Thrasher became the first woman president of a senior class at Auburn.

(Above left) SCULPTOR. In 1946, Jean Woodham became the first woman to edit the *Glomerata*. An art alumnus who taught at Auburn, Woodham is best known on campus for her 18-foot-tall sculpture in front of the Goodwin Hall music building and her international recognition as an artist.

(Above right) VETERINARY LEADER. Dr. Bobbye Alexander Chancellor '51 was the first female veterinarian elected to the office of vice president of the American Veterinary Medical Association (AVMA). She was the first woman to win a national AVMA position and served in that office from 1977 to 1979. This position permitted her to cast influential executive board votes to shape the veterinary profession. Chancellor was a veterinarian for the U.S. Department of Agriculture in Mississippi. When she graduated from Auburn, Chancellor was pregnant with her son, James E. Chancellor III, who graduated from Auburn's veterinary school in 1976. The veterinary school's magazine humorously noted that he had crossed Auburn's graduation stage twice, in utero and as an adult.

DOCTORAL FIRST. Birmingham native Margaret Malone Baskervill '58 was the first woman to receive a Ph.D. from Auburn. She completed her doctorate in mathematics, working with Prof. Nathaniel Macon as her advisor. Her dissertation was titled, "The Generation of Error in the Computation of Continued Fractions." Prior to her studies at Auburn, she earned degrees from Randolph-Macon Woman's College and the University of Michigan. She was employed as a mathematics instructor at Auburn from 1943 to 1947 and then became a professor at Georgia's Shorter College.

SPACE. Thomas Mattingly '58 was student body president when the football team won the national championship and led a celebratory pep rally. He and fellow Auburn alumnus Hank Hartsfield '54 were pioneer space shuttle pilots. Auburn has played an active role in the American space program, from the first moon landing to the present. Space shuttles often transport Auburn experiments. Auburn alumni have been prominent administrators, including James W. Kennedy '72, who has been director of both the Marshall Space Flight Center and the Kennedy Space Center (where three Auburn men have been directors.) Auburn astronauts included C.C. Williams '54, who died before his lunar mission. He had planned to shout "War Eagle!" as his first words on the moon.

WIRELESS PIONEER. Samuel L. Ginn '59 from Anniston benefited from his Auburn engineering education to innovate wireless communications. He donated $25 million to Auburn, where the College of Engineering was named for him. His funds helped Auburn create the first bachelor's degree program in wireless engineering in the United States. As a result, Auburn is a leader in the global wireless revolution.

QUEENS. Catherine Bailey '52 was named Maid of Cotton in the early 1950s. Many Auburn women have won that title or worn the crown for other pageants for fairs, organizations, or a variety of interests, such as Chris Akin '66 being named Miss Football USA in 1965.

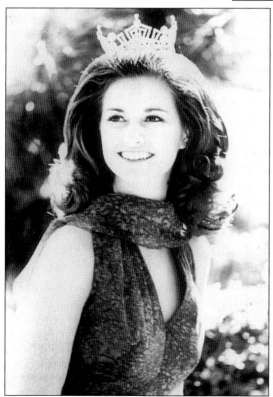

MISS ALABAMA. Frieta Fuller '74 won the 1972 Miss Alabama pageant. Other Auburn coeds who earned that title and were runners-up at the Miss America pageant include Angi Grooms Proctor '68 in 1966 and Jenny Jackson '89 in 1988. Alumnus Catherine Crosby was named Miss Alabama in 2003.

STATE LEADER. Kay Ivey '67 won five elections when she was at Auburn. She was the first coed who won the office of vice president of the student body. In that role, she is pictured here with guest speaker Representative Armistead Selden. Ivey also served as president of the SGA Senate. She won numerous awards, including Outstanding Senior of five campus groups. After she graduated, Ivey served as an Alabama Higher Education commissioner and received appointments from three Alabama governors. A Republican candidate in the 2002 election, she won the office of Alabama state treasurer. Auburn named Ivey an Outstanding Alumni in 1996.

SAMBO. Samuel "Sambo" N. Mockbee '74, an architecture professor, proudly gestures to a Rural Studio creation. The recipient of a MacArthur Foundation Genius Grant and funds from Oprah Winfrey, Mockbee gave all the money to the Rural Studio. Acutely aware of poverty, he stressed social responsibility and insisted his students build a dormitory near the recipients of their designs. "Kids who want to be architects should be out there learning about the people they'll be working for," he emphasized. After Mockbee's death in 2001, his colleague Dr. D.K. Ruth eulogized, "The world is a better place because of Samuel Mockbee."

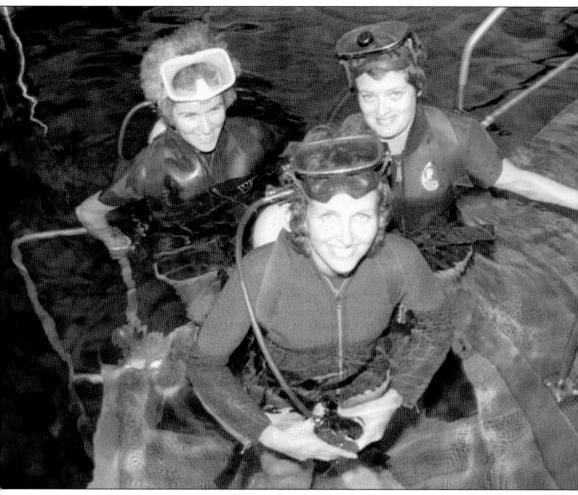

Space Pioneer. Ann Fite Whitaker '89, on the right, earned an Auburn doctorate in mechanical engineering. Her dissertation described how oxygen plasma affects polymers. Researching the effects of space on materials at Huntsville's Marshall Space Flight Center, Whitaker developed lubricants for the tractor crawler used to transport Saturn rockets to the launch pad. She developed an instrument for Skylab and participated in Spacelab training, such as working in the neutral buoyancy simulator at Marshall, to better understand space conditions to develop experiments. Whitaker was designated a payload specialist candidate and would have been the first American woman in space if she had been selected for that flight. She continued investigations at MSFC, contributing to the understanding and development of aerospace endeavors for the shuttle and International Space Station, as the head of the Materials and Processes Laboratory and director of the Science Directorate.

PULITZER. In 1988, Mary Emily Bentley '86 became the first Auburn alumnus to win a Pulitzer Prize. She is pictured with Auburn alumni, Jay Sailors '87 and Nancy King Dennis '80, who assisted the *Alabama Journal* team that wrote the prize-winning series about infant mortality. Sailors photographed subjects, and Dennis edited copy.

ABILITY. Kim Mensi, who earned a bachelor's degree in education in 1989 and a master's degree two years later, was named Miss Wheelchair Alabama and Ms. Wheelchair America in 1993. She raised campus awareness of disability issues.

Six

PATRIOTS AND HEROES

GLORY. ROTC cadets representing
major service branches display
flags with military and Auburn
symbols. Auburn University's
military tradition spans the
college's life. Many prominent U.S.
officers, including the father of
amphibious warfare, Gen. Holland
Smith '01 (Marines), and former
U.S. Marine Corps Commandant
Gen. Carl Mundy Jr. '57, attended
Auburn. Until the late 1960s, all
male students were expected
to participate in military drills.
Many modern students elect
to affiliate with ROTC units.

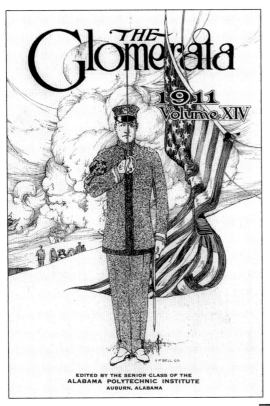

PATRIOTISM. The 1911 *Glomerata* began with this patriotic image. Yearbooks also used words to show Auburn's military dedication, stating that in 1917 "the War Eagle began to sharpen its talons for the great fight of humanity, to make the world safe for democracy," and "from Maine to California, from the Lakes to the Everglades, thousands of true sons of Auburn assembled to fight and die beneath the glorious Stars and Stripes of America."

GENERAL BULLARD. Gen. Robert Bullard was a member of Auburn's Class of 1882 before he graduated from West Point. He served in the Spanish-American War and commanded the First Division of the American Expeditionary Forces in World War I, receiving honors from President Woodrow Wilson. The 1919 *Glomerata* was "affectionately dedicated" to "our distinguished leader and Alumnus Lieut. General Bullard who went forth in the struggle for Democracy and added glory to himself and Auburn."

Tribute. The 1919 *Glomerata* contained this title page that paid tribute to Auburn's doughboys. Half of the class of 1918 had entered service "super-charged with the indomitable, unquenchable Auburn Spirit." Other illustrations in that yearbook included "Our Service Flag," which had stars forming the number 2,000. Another image read, "Between the Crosses, Row on Row, In Flanders Fields, the Poppies Grow," stating, "In Memoriam Auburn 1919." A plaque commemorating Auburn's World War I servicemen is displayed in Foy Union. Casualties included aviator Billy Glenn Rushing '15, who died in France.

Organizations. Auburn cadets and veterans formed groups representing their military interests and allegiances, such as the Shave Tails in 1919. The War Students' Association gathered to discuss veterans' concerns and documented which Auburn men had received the Croix de Guerre in the Great War.

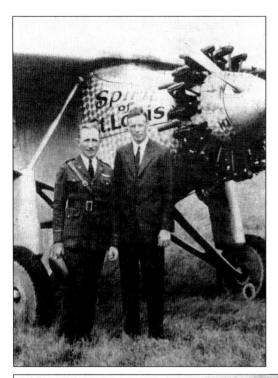

LONE WAR EAGLE. The appropriately named Auby C. Strickland '18 was legendary aviator Charles Lindbergh's flight instructor. Teacher and pupil proudly posed together in front of Lindbergh's famous airplane. Strickland's military career included World Wars I and II service, more than 6,500 flying hours with the Army Air Corps and its successors, and promotion to the rank of brigadier general. A street at the Gunter Air Force Station housing complex in Montgomery is named for Strickland, who had been an Air Corps Tactical School student at Maxwell Air Force Base.

CLASS OF SERVICE

This is a full-rate Telegram or Cable-gram unless its de-ferred character is in-dicated by a suitable symbol above or pre-ceding the address.

WESTERN UNION (32)

W. P. MARSHALL, PRESIDENT

The filing time shown in the date line on telegrams and day letters is STANDARD TIME at point of origin. Time of receipt is STANDARD TIME at point of destination

```
WPO45 RX PD=NCU NEWYORK NY 30 318P=
THE HONORABLE LOUIS JOHNSON, THE SECRETARY OF DEFENSE=
    THE PENTAGON=

I CANNOT LET PASS THIS OCCASION WHEN SO MANY OF HIS FRIEND
AND COMRADES HAVE JOINED IN TRIBUTE TO MAJOR GENERAL WILTON
B PERSONS WITHOUT MYSELF SALUTING A SOLDIER WHOSE
PERFORMANCE OF DUTY HAS ALWAYS BEEN OUTSTANDING WHOSE
EXPERIENCE AND KNOWLEDGE WERE OF INESTIMABLE SERVICE TO
ME DURING MY TOUR AS CHIEF OF STAFF, WHOSE PERSONAL
FRIENDSHIP I HAVE ALWAYS PRIZED=
    :DWIGHT D EISENHOWER=
```

WHITE HOUSE. President Eisenhower selected Auburn alumnus Maj. Gen. Wilton Persons to be his deputy assistant in the White House in 1958. Media credited Persons for maintaining an efficient, congenial working atmosphere in the White House. After his term, Eisenhower remained in contact with Persons, whom he addressed by his nickname "Jerry" and expressed "my appreciation of the splendid services you rendered in the Army," signing messages "Ike."

GENERAL HART. Maj. Gen. Franklin A. Hart '15 served as commandant of the U.S. Marine Corps. In that position, he often encountered Auburn alumni who made sure to let Hart know of their shared alma mater. At Auburn, Hart played football and soccer and participated in track events. He fought in the World Wars and received the Navy Cross for heroic actions in the South Pacific.

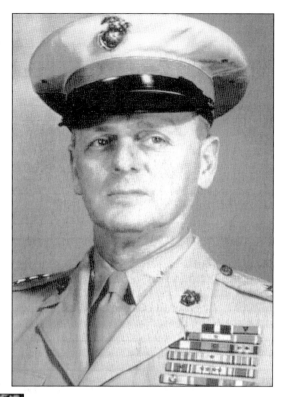

ARNOLD AIR SOCIETY. Auburn's chapter of the Air Force ROTC Arnold Air Society is named in honor of John "Boots" Stratford '41, who died while serving as a fighter pilot on a mission over Germany in World War II. The John B. Stratford Squadron was established in March 1951 to honor cadets' leadership and service.

ALABAMA POLYTECHNIC INSTITUTE
Vol. 3 Agricultural Engineering Department No. 4
Auburn, Alabama

August 31, 1944

AG ENGINEERING ALUMNI AND FORMER STUDENTS

Dear Friends:

I am ashamed for being so slow in getting out another News Letter, especially after getting such a good response after the last letter.

Ensign B. E. Young wrote from somewhere in the English Channel that he was busy ferrying the boys across for the invasion. Young is in charge of an L. C. I. boat. Young says that he likes Alabama weather much better than he does that of England. On a short leave he had in May, he ran into his former Soils Lab instructor, Mr. Wilson, who is doing aerial photography.

I have received two letters from Captain Snellings since the last News Letter, the first one written in May and the second one June 23. I also just got word through his brother, Robert, who has been in school, that Ross has suffered a shrapnel wound in the leg. We hope that you are soon up and at 'em again, Ross. Ross's young brother thinks he is about well as he has been writing about the beautiful nurses. It looks as though Johnson is going to have to stay on in the fight since you are laying down on the job.

I got a letter from Capt. Johnson written early in June saying that he had been so busy chasing "krauts" that he hadn't had time to eat or sleep. At that time he was on the way to Rome, so he has done a good job chasing them as they are in northern Italy now. Another letter came in today saying that he had had a few weeks rest and had had his first leave in the 25 months he has been in action. He said he took in the city of Rome and certainly enjoyed the beautiful sights. He said that the people dress nice but I think he really meant the young girls. He said he knew the Italians had good grain and vegetable crops because he sampled them as he marched through the fields.

Major Lawrence Ennis got his promotion last June and is still in Italy on last report. He received the Purple Heart for his work on Anzio beach-head. He also got a slight wound but is back in the fight again. He says the people living in southern Italy are poor, ignorant and lazy while those in northern Italy are prosperous and have beautiful homes. Lawrence has an Italian college professor for his orderly and the professor has become so attached to him that he wants to come back to America with him.

Lt. Turner N. Williams wrote from somewhere in England just before D-day but I expect he has landed in a parachute somewhere behind the German lines as he is in a Parachute Field Artillery Battalion.

I received a letter from Lt. Alsobrook written shortly before D-day and he said he was going to look up Luther Brown. He had run into a number of A.P.I. men but so far, no Ag. Engineers. He said he met his old room mate, Jimmy Nix, who shoots a lot of bull about working hard, but the seat of his pants was the dirtiest part about him. Quite a game dominoes! You know it takes at least 2 to play dominoes. I got another letter written June 4 in which he said he had seen Luther and had a very

SINCE YOU'VE BEEN GONE. Agricultural engineering department head Dr. Jesse Neal prepared a newsletter he sent to students, alumni, faculty, and staff serving in World War II and their families. The subscription was a return letter to Dr. Neal. He reported news from the Auburn homefront of the department and campus as well as telling recipients about the others' wartime activities, promotions, and awards, and sometimes, sadly, about casualties or prisoners of war, in addition to personal news about marriages and births. Neal told readers about the status of football at Auburn and promised them chicken dinners when they returned to the Plains.

HOMETOWN HERO. Lozier Hendry '36, whose father was Auburn's police co-chief, died in the Philippines in a Japanese prisoner-of-war camp. A marker in Auburn's Pine Hill Cemetery memorializes his sacrifice. Hendry participated in advanced ROTC at Auburn and was commissioned a second lieutenant on graduation day. Promoted to first lieutenant, he was sent to the Philippines before the Japanese attack on Pearl Harbor. Hendry retreated with American forces in January 1942 to Bataan, managing to slip a note to be mailed to his family that he had a premonition he would not survive. The troops surrendered in April, and Hendry died as a prisoner on May 21, 1943. Japanese officials stated malaria was the cause of death.

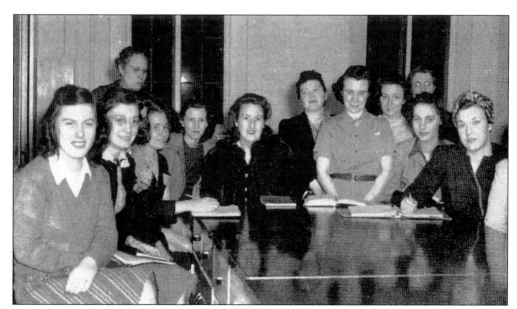

HOMEFRONT. During the World Wars, Auburn was transformed when many male students enlisted, and soldiers were brought to campus for radio and other military training. These coeds supported the war effort by forming Women for Defense in 1942. The women sold war bonds on campus, collected goods to ship to soldiers, grew liberty gardens, and performed other patriotic deeds.

93

TANKS. Philip W. Lett '44 is considered the father of the M-1 tank. A native of Newton in southeastern Alabama, he studied mechanical engineering at Auburn. He applied that prowess to World War II service in the Corps of Engineers and graduate studies at the Universities of Alabama and Michigan and the Massachusetts Institute of Technology. An engineering executive at Chrysler Corporation, he pursued defense research and development. The M-1 tank was designed specifically to protect crews from enemy damage. Design improvements created the M1-A1 Abrams Tank, which helped Allied forces to efficiently defeat the Iraqi Army without sustaining tank crew casualties during the first Gulf War.

WAR DOG. Dr. William Putney graduated from Auburn's veterinary school in 1943. In the Second World War, he was commanding officer of the 3rd Marine War Dog Platoon. During the war, he developed innovative field methods to treat dogs for heartworms and other parasites encountered in the tropics. Years after the war, Putney led the drive to erect this monument in the war dog cemetery on Guam in 1994 for the 50th anniversary of its liberation from Japanese forces. He wrote about the canine soldiers in his book *Always Faithful*. Replicas of the statue are located at the American Kennel Club Museum in St. Louis, Missouri, and at the University of Tennessee, where Auburn alumnus Dr. Mike Shires was dean before accepting the same position at St. Kitts's Ross University. Auburn has continued its support of working dogs, particularly the training of bomb detection dogs.

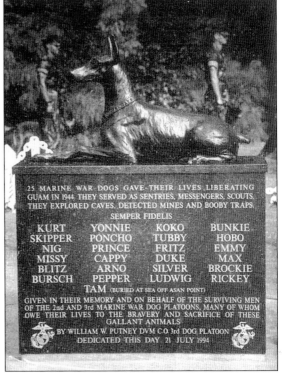

HOME-FRONT NEWS

Published Monthly for Members in the Armed Forces by the Bruce McGehee Bible Class of the Auburn Methodist Church

Volume III Auburn, Alabama, U.S.A., June, 1945 Number 9

Major General Pick Visits in Auburn

Major General Lewis A. Pick, commanding general, advance station No. 3, India-Burma theatre, was in Auburn recently for a visit with his wife, Mrs. Lewis A. Pick, and his wife's mother Mrs. C. A. Cary. Gen. Pick is the builder of the Ledo Road of fuel and pipe lines from Assam, India into Western China. He has maintained his official residence in Auburn for many years. The General was at one time connected with the R.O.T.C. unit here.

———V———

Bronze Star for Major Francis

Major William Hugh Francis, class member, has been awarded the Bronze Star Medal. Major Francis, a member of the 151st F. A. battalion of the 34th Division, won the award for his part in the action that broke the Gothic Line. As artillery liaison officer to an infantry regiment, he directed and co-ordinated artillery in support of the regiment's advances.

THOSE HEARD FROM

Major Jack Dandridge, Air Corps intelligence, writes from a hospital in Santa Monica. He is about well and ready for assignment.

Sarah Tant, WAVE, writes she enjoys the Home-Front News and sends it overseas after letting her friends read it.

Lt. C. T. Harkins, USMC, writes that as yet he has not seen action — but is getting closer.

Lt. Bob Day, pitcher on '41 baseball team, is stationed at Larado, Texas. Bob and his good looking wife were recent visitors.

Ens. James E. Land, USNR, visited in Auburn recently on a final 10-day leave. When last heard from he was still waiting in San Francisco.

Lt. Mays Montgomery is back in the U.S.A., after being injured on the Italian front.

Major Earl R. "Preacher" Smith writes from Florida that he is enjoying the Home-Front News.

Notes of Interest About Auburn and Auburn Men

Auburn is among 27 colleges and universities recently selected as a center for training Naval Reserve Officers Training Corps. Courses will begin here on approximately November 1, after National abandonment of V-12 programs. This training will be in addition to and not in lieu of the Army R.O.T.C.

One hundred sixteen candidates received degrees at API's Spring graduation ceremony. Director of Instruction, Ralph B. Draughon, was the speaker for the occasion.

M. J. Funchess, dean of agriculture, API, and director of Alabama Agricultural Experiment Station, has been requested by the National Research Council, Washington, D. C., to serve as a member of its Agricultural Board.

Auburn's R.O.T.C. has again won the rating of "excellent" after Federal inspection by Major Martin R. Rice on April 23.

V. W. Lapp, professor of physical education, has been granted a leave by API to teach for six weeks at U. C. L. A., beginning July 1.

———V———

V-E Day Celebrated in Auburn With Prayer and Thanksgiving

V-E day was celebrated in Auburn with a note of humility and thankfulness. Large crowds attended services in the several churches of the city. All business houses in Auburn were closed from ten to twelve o'clock Tuesday morning and again at four in the afternoon when one of the largest crowds of Auburn citizens ever assembled in the Auburn Stadium — other than for a football game — gathered for a service of prayer and thanksgiving.

Dr. Fagan Thompson (Methodist) conducted the song service, Rev. William Byrd Lee (Episcopal) gave the prayer, and Rev. Sam B. Hay (Presbyterian) gave the principal address.

———V———

Lt. Governor Handy Ellis gave the Mothers' Day address in the service sponsored by the McGehee Bible Class on Sunday Morning, May 13. A barbecue was had for him in Graves Center the evening before.

———V———

Decorations and Promotions for Auburn Men

Maj. Tom M. Martin, Jr., the Bronze Star Medal for meritorious service during the period August 12, 1944 to April 2, 1945 in France, Luxembourg, and Germany; Lt. John M. Druary, the Bronze Star Medal on March 15 for bravery in action against the Germans. He is in the F. A. in the 9th Army.

Lt. Ike W. Pitman, the Air Medal for meritorious achievement in aerial flight against the enemy; Capt. James Doughtie, the Purple Heart for wounds received in action against the Japs; Lt. Mike W. Baldwin, the Bronze Star for

gallantry in action in the Mediterranean theater; Lt. James Foster, the Air Medal for meritorious achievement in aerial flight against the enemy; Capt. Charles W. Ryder, the Silver Star for gallantry in action; Pfc. Martin L. Beck, the Bronze Star Medal for action against enemy.

S/Sgt. Harry Isbell, the 5th Oak Leaf Cluster to the Air Medal for meritorious achievement while participating in 8th Air Force bombing attacks on Germany; Sgt. Nelson Howard, the Silver Star for gallantry in action in the Philippines; Capt. Doug C. Wallace, 2nd Armored Division, Distinguished Service Cross. He is also editor of Camp paper "Hell on Wheels."

1st Lt. Jack Butler, Purple Heart, for wounds in Germany; 1st Lt. S. E. Wallace, Bronze Star for aerial artillery in the Philippines.

James B. Richards, Jr., to 1st Lt. in the Army Air Corps in Italy; Robert Newton Campbell to Captain; John C. Ball to 1st Lt. — who has been in combat in the European theater for several months. Robert D. Knapp, Jr., to Staff Sgt. in the Mediterranean area; George M. Salter Jr., to Capt. at an 8th Air Force

Auburn Men Liberated

Lt. Forrest Nixon, who was shot down over Germany, April 24; Lt. Albert Thomas, who parachuted down over Munich last July; Pfc. Merville Hebert and Pfc. Martin L. Beck, who were captured in the Belgium bulge.

Lt. Neal Harris, whose plane was shot down over Germany March 3, 15 miles outside Berlin. The first man Neal met after being liberated was Capt. "Rat" Reynolds.

Lt. Jack Ferrell, who was shot down over Holland in late 1944, has been lib-

HOMEFRONT NEWS. The Auburn United Methodist Church has close ties with the college community. This newsletter reported good news of promotions and safely completed missions in items headlined "War Eagle" and sad news of captures and casualties. In the June 1945 newsletter, readers were told that former Auburn military professor, Maj. Gen. Lewis A. Pick, had visited his Auburn home after overseeing construction of the fabled Ledo Road in Asia. Pick had married veterinary dean Charles A. Cary's daughter, Alice. Other prominent Auburn people mentioned include agricultural dean Marion J. Funchess and pioneering airmail aviator Robert D. Knapp Jr.

ARMORY. The city of Auburn's National Guard armory was named for Maj. Gen. Charles A. Rollo, a World War II veteran and Auburn agricultural engineering alumnus. Rollo taught in the agricultural engineering department. Gov. George C. Wallace named him state adjutant general of the Alabama National Guard.

DRILL FIELD. The drill field where ROTC cadets used to drill was named in honor of Max A. Morris '42, who was killed while serving near the Chosin Reservoir during the Korean War. Morris had played football at Auburn. He received a Carnegie Medal for risking his life to save a cadet at ROTC summer camp at Fort Benningw in 1941. Morris also served in World War II. The drill field is now a parking lot that retains Morris's name on campus maps.

96

ROSE GARDEN. President Ronald Reagan honored Auburn cadet Edward Gibbons in a 1983 ceremony in the White House's Rose Garden. Gibbons had been designated the best Army ROTC graduate in the United States. In 1981, he had been ranked first at the National Army Ranger School at Fort Benning.

POW-MIA. Many Auburn students have worn bracelets engraved with the names of soldiers declared missing in action. ROTC students erected a bamboo cage on the concourse to alert students of the plight of prisoners of war. Jean Fallon, Miss Auburn 1988, and her sister, Cappie Fallon, often told the campus community about their father, Col. Patrick M. Fallon, a decorated World War II and Korean War veteran who was commander of the 56th Special Operations Wing during the Vietnam War. His last radio transmission stated, "I'm hit" after he bailed out from his aircraft during a mission near the Thailand-Laos border on July 4, 1969. Since then, rumors that he has been held prisoner in Laos have circulated. The family remains hopeful, educating people about servicemen lost during secret actions in Laos. Sadly, in 1988, alumnus Col. William R. Higgins was kidnapped in Lebanon and murdered by terrorists while in captivity.

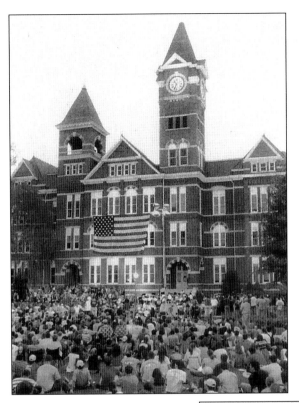

9/11. After the September 11, 2001 terrorist attacks, the Auburn community joined together to grieve. Candlelight vigils were held, and American flags were displayed on campus. This memorial service was organized in front of Samford Hall. Students placed flags in dormitory and apartment windows in support of American troops serving in Afghanistan. Flags remained when U.S. troops entered Iraq in 2003, and Auburn gained national attention when Birmingham native Ian Hogg flew an Auburn flag on his military vehicle entering Baghdad and the Associated Press distributed that image worldwide. Auburn gave Hogg a full scholarship as a result. Christopher Robert Willoughby, a 2002 accounting graduate, died while serving in Iraq.

WTC. After Mary Lynn Edwards Angell '71 graduated from Auburn in early childhood education, she earned a library degree from the University of Rhode Island. She supported her husband, David Angell, during his fledgling television writing and producing career, which resulted in such classic programs as *Cheers* and *Frasier*. The couple was aboard the first hijacked airplane that struck the World Trade Center's North Tower on September 11, 2001. Friends reminisced that Lynn Angell brought Southern charm and graciousness to everything she did.

PENTAGON. When the hijacked airplane hit the Pentagon on September 11, 2001, it struck Marjorie Champion Salamone's office first. A native of Pine Mountain, Georgia, Marjorie enrolled at Auburn when she was 16 years old and earned bachelor's ('68) and master's ('70) degrees with honors in textile chemistry and consumer affairs. She met her husband, veterinary graduate Col. Bernard P. Salamone '70 at Auburn in an organic chemistry class. Salamone worked as a civilian budget analyst for the Department of Defense at the Pentagon when they settled in Springfield, Virginia. Auburn presented Salamone the Outstanding Textile Engineering Alumna Award in 2002. Her husband, parents, brother Dr. Richard Champion '65, and college roommate, Charline Cumbee Hand '68, attended the ceremony. Salamone was buried in Arlington National Cemetery. Her stone reads, "She was true to her spirit, her convictions, her family and country."

PATRIOTISM. Johnny Micheal "Mike" Spann '92 devoted his life to serving his country. As a teenager in Winfield, Alabama, he dreamed of attending Auburn. Majoring in criminal justice/law enforcement, Spann served in the Marine Corps after graduation before joining the CIA as an intelligence officer in the Directorate of Operations in 1999. He was in Afghanistan, interrogating Taliban and al-Qaida prisoners, when he was killed during a prison uprising at Mazar-e-Sharif on November 25, 2001. Spann was the first American combat casualty in Afghanistan after military action retaliating for September 11, 2001 terrorism began. Eager to serve in Afghanistan, Spann wrote, "I am an action person who feels personally responsible for making any changes in this world that are in my power." The Alabama legislature passed a resolution commending Spann's service. Auburn lowered flags to half-mast to honor Spann and also commemorated him on Memorial Day. There is an Auburn scholarship endowment in Spann's honor and all Auburn military personnel who have died in service. Spann was buried in Arlington National Cemetery.

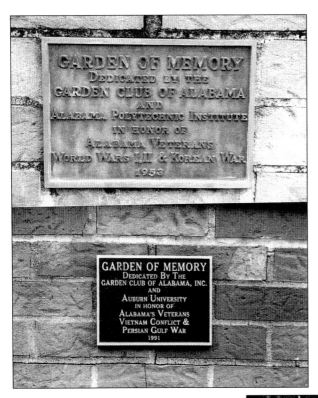

MEMORIAL. Auburn and the Garden Club of Alabama created a Garden of Memory in honor of veterans. The peaceful garden is located between the president's mansion and the Hill Dorms. Brick steps descend to a grassy area where people can study and relax on benches. A bridge spans a creek flowing through the area. Colorful cannas, marigolds, petunias, and other flowers accent ornamental plantings of pampas grass and foliage. The names of alumni such as Charles M. Earnest '55, killed in Vietnam, appear on national memorials in Washington, D.C.

TIGER STORM. When Auburn soldiers were called for service in the first Gulf War, the community supported them. Students, staff, and faculty displayed the American flag, prepared signs reading "Tiger Storm," and held candlelight vigils. Two Auburn alumni died during Desert Storm: Dale T. Cormier '82 and James N. Wilbourn '84.

Seven

TRADITIONS

AUBURN CREED. History professor George Petrie was Auburn's first football coach in 1892. Fifty years later, he wrote "The Auburn Creed," emphasizing virtues of Auburn people, especially that of respecting each other. Petrie also stressed a work ethic, education, service, honesty, empathy, patriotism, and health, declaring, "because Auburn men and women believe in these things, I believe in Auburn and love it." Alumnus Dabney Otis Collins '11 described him as "Dr. Petrie of the shiny dome and gentle nature."

GLOMERATA

A College Battle Song

A college song and a college yell
 And a clinkling farewell glass,
A campus stroll and a parting pledge
 To the wistful Auburn lass;
Then off to war in the battling world
 And the clash of arm and brain,
The stifling moil of the surging crowd
 And the heat of the blistered plain.

And some there be of the swarming host
 In the thick of the fight shall rise,
While some will fain ere the sun swing out
 On the march of the morning skies,
And some will forge to the foremost rank
 By the right of might preferred,
While some will plod in the listless way
 Of the undistinguished herd.

A campus stroll and a parting pledge
 To the wistful Auburn lass,
A college song and a college yell
 And the clinkling farewell glass:
A health to him of the mighty arm
 In the ranks with us to-day,
Then off to war in the battling world
 With a rousing hip-hooray.
 —From "Rings o' Smoke," by Clarence N. Ousley, '81.

18

SCHOOL SPIRIT. Before Auburn's famous fight song was composed, students created poems and lyrics to express their pride in Auburn. "A College Battle Song" provides the words to boost school spirit during wartime. No known music was composed to accompany 1881 alumnus Clarence N. Ousley's patriotic sentiments.

CAKE RACE. Fred Carley '49 is shown winning the 1943 ODK Cake Race. Track coach Wilbur Hutsell started this race at homecoming in order to identify talented athletes and reward them with home-baked cakes. Omicron Delta Kappa honorary sponsors this race every fall, and students, staff, faculty, and alumni can participate. Runners begin and end at the Wilbur Hutsell Track on a 3.2-mile course through campus. Everyone receives a t-shirt, and the male and female winners receive a cake and kiss from a student leader, usually Miss Auburn and the SGA president.

BEAT BAMA. Fans and players, still excited about the 1957 national championship, gathered to appear on this televised pep rally the next year to support the team. The game versus Alabama evoked strong emotions and intensified school spirit. The stuffed eagle was displayed at athletic events when a live eagle was unavailable.

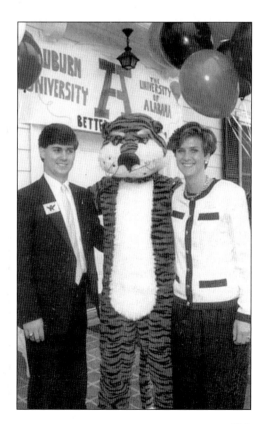

AUBIE. Aubie's sassy spirit has enchanted the Auburn community for decades. *Birmingham Post-Herald* cartoonist Phil Neel first drew Aubie for football programs in 1959. By 1979, students donned an Aubie costume and a bold persona. Aubie does not hesitate to mock rival mascots, dance provocatively, act outraged at referees' calls, blow kisses to crowds, and woo attractive coeds. Aubie has won the national mascot competition several times. In this picture, Aubie and 1989–1990 SGA president Scott Turnquist '90 greet a campus visitor.

FIGHT SONG. Roy B. Sewell '22, an outstanding alumni leader and wealthy clothing manufacturer, hired Al Stillman to write lyrics and Robert Allen to compose music for Auburn's fight song. The Auburn Alumni Association copyrighted "War Eagle" in 1955 and it was first played at the Auburn-Chattanooga game in September. Bill Wood '24 wrote the words and music for Auburn's "Alma Mater," which also is often played at Auburn events. "On the rolling plains of Dixie," Wood wrote, "We hail thee, Auburn, and we vow/To work for thy just fame,/ And hold in memory as we do now/Thy cherished name."

WAR EAGLE. Several legends are circulated to explain the tradition of Auburn having a golden eagle as a mascot. A popular version states that the first Auburn eagle was the pet of a Civil War veteran who had saved the bird on a battlefield. When the eagle flew above the field during a 1890s Auburn-Georgia game, Auburn fans shouted "Look at the war eagle!" and credited the eagle with inspiring the team to be victorious. The current War Eagle, nicknamed Tiger, was maintained by Alpha Phi Omega service fraternity until the late 1990s when she was transferred to the veterinary school's raptor center. Tiger flew at the 2002 Salt Lake City Winter Olympics opening ceremony. Eagle trainer Greg Turnquist '95 is pictured with Tiger.

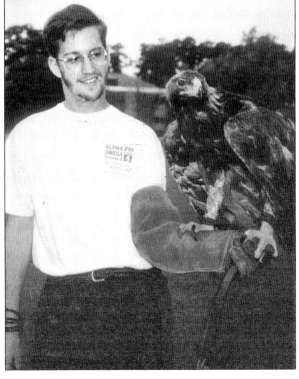

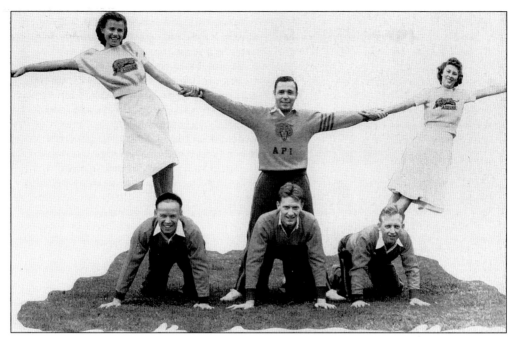

RAH! Informal cheerleading occurred when Auburn students competed in the first athletic events on campus and friends verbally encouraged them. At games with other schools, students wore school colors, sang songs, and made signs to express their devotion to Auburn. Male cheerleaders were selected in the early 20th century. The first official female cheerleaders, Doris Greene and June Tooker, appeared on the field in 1937.

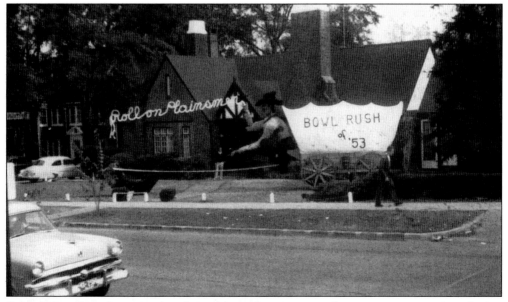

CREPE PAPER. Every homecoming, fraternities compete to see who can construct a prize-winning float. These chicken wire and crepe paper creations line the yards of fraternity row. Usually, each float is designed to depict Auburn soundly defeating, sometimes maiming, the team selected to challenge them on homecoming day. The floats often are amusing caricatures, although some are quite artistic.

NAME *Jeanne Swanner*

HOMETOWN *Graham, N.C.*

HEY DAY. Auburn is known for its friendly atmosphere and the idea that everyone is welcome on campus and that no one is a stranger. One favorite tradition is Hey Day. Students are encouraged to wear nametags and greet everyone they encounter. A variety of activities, musical performances, dances, and games are scheduled to help students become acquainted. A Miss Hey Day is selected from female students, who undergo an interview process that evaluates their friendliness and how well they represent the essence of Auburn. Students vote for a winner from five finalists. This Hey Day nametag belonged to Jeanne Swanner Robertson '67, former Miss North Carolina and Miss Congeniality at the Miss America pageant.

SWEETHEARTS. Many students fall in love at Auburn. When Carolyn Carr, one of the first female chemistry majors at Auburn, hired Howard Carr to tutor her, they discovered true chemistry. Smitten by Carolyn, Howard refused to accept payment. The couple married and stayed in Auburn, where Howard was a physics professor for several decades. He taught several of Auburn's astronauts. Former student C. Harry Knowles '51, a designer of transistors and barcode scanners who was inducted into the New Jersey Inventors Hall of Fame, and his wife, Janet, endowed the Howard and Carolyn Carr Chair in Physics in gratitude to the couple's friendship when he was at Auburn.

106

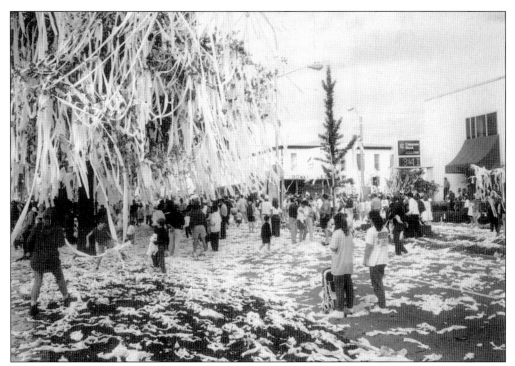

TOOMER'S CORNER. After sports victories, people congregate at Toomer's Corner to roll it with toilet paper to express their jubilation. That corner often resembles a blizzard scene, particularly after Auburn defeats archrival Alabama at home. Wherever you are, you can observe celebrations at http://www.toomerscornerlive.com. Generations of students have enjoyed a tart Toomer's lemonade, which is an Auburn tradition for dates and sweltering summer afternoons.

TIGER RAGS. Since 1983, Tiger Rags (http://www.tigerrags.com) has created and sold a variety of unique Auburn apparel. Producing trademarked shirts for each football game every season, Tiger Rags also designs shirts to commemorate such Auburn victories as NCAA National Championships for both the women's and men's swim teams. Athletic shirts feature a stylish, strong tiger besting caricatured opponents and display catchy slogans. Auburn fans can join Tiger Rags' Spirit Club to receive a complete set of football shirts and a club shirt plus discounts on merchandise and exclusive sales invitations.

WRECK TECH. Mary Ben Savage '87 and Sandy Gibbs Murphy '87 cheered their Alpha Gamma Delta pledge sisters at the 1986 Wreck Tech pep rally. The Auburn-Georgia Tech rivalry was the theme of an annual parade through campus until those teams stopped playing football against one another in the 1980s. Participants traditionally wore pajamas. Sorority pledges yelled cheers and waved shakers. Fraternity pledges carried floats to Jordan-Hare Stadium for a pep rally. Other football rivalries inspired Auburn traditions such as the "Burn the Bulldogs" parade in which students march to a nearby field for a pep rally and bonfire. The Wreck Tech parade was revived in 2003 when the football rivalry was resumed.

TRADITIONS. The Jordan-Hare football stadium is decorated with artistic panels that depict aspects of the university's football history and culture. Michael Taylor prepared the murals to be unveiled for the 1998 football season. This panel features traditions familiar to Auburn fans. Before each home game, the players undergo the Tiger Walk, during which fans cheer the team as it passes through the crowd from the dressing room to the stadium.Other murals on the stadium depict Auburn's coaches since the 1890s including John Heisman Trophy winners Pat Sullivan and Bo Jackson, and the 1993 team and Coach Terry Bowden, who won every game Auburn played that season. A-Day, the annual spring intrasquad game, is another Auburn tradition.

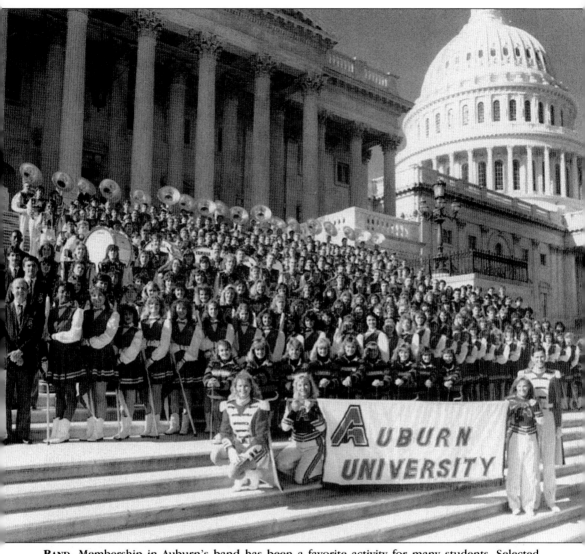

BAND. Membership in Auburn's band has been a favorite activity for many students. Selected by auditions, members practice for athletic performances and special events such as marching in the January 20, 1989 inaugural parade for President George H. Bush and Vice President Dan Quayle, who later visited Auburn's campus. The band officially represented Alabama. Marching Band Director Dr. Johnnie Vinson secured an invitation through Alabama's Congressional members. While posing on the Capitol steps, the band played "War Eagle." The Auburn band had previously marched in President Harry S Truman's 1949 inaugural parade. Band members enjoy camaraderie, which helps them present finessed, synchronized half-time shows. Auburn's band plays traditional Auburn-related tunes such as "Tiger Rag," "Eye of the Tiger," and "Hold That Tiger" in addition to popular culture favorites such as "Louie, Louie."

SGA ELECTIONS. Vania Clemons, pictured here, was the first African-American student elected Miss Auburn. In 1987, Howard Melton became Auburn's first African-American SGA president, and the next year later Cindy Holland became the first female SGA president. The annual Student Government Association elections take place every spring. Campus bulletin boards are covered with candidates' handbills. Flyers are posted on buildings and the concourse, and large painted plywood signs promoting people running for the top SGA offices and Miss Auburn are placed in pickup trucks parked at Toomer's Corner. Candidates spend election week visiting fraternity houses, sorority chapter rooms, and club meetings in an effort to convince students to vote for them. Most candidates create a logo, photographic image, or slogan to attract voters and help them remember the candidate's name when they cast their votes.

CAMP WAR EAGLE. Freshmen and new students can become acquainted with the Auburn campus during Camp War Eagle sessions held every summer. Parents are welcomed to accompany their children at the camp. Upperclassmen try out to become counselors who serve with several university professionals. They help incoming students become comfortable at Auburn before arriving for the fall semester. Participants learn how to function at Auburn and make friends with other new students during fun activities. Counselors perform skits, make presentations, lead pep rallies, and offer practical advice to help people survive their freshman year. These Camp War Eagle counselors posed in front of Samford Hall and the new campus gates at the intersection of Thach Avenue and College Street.

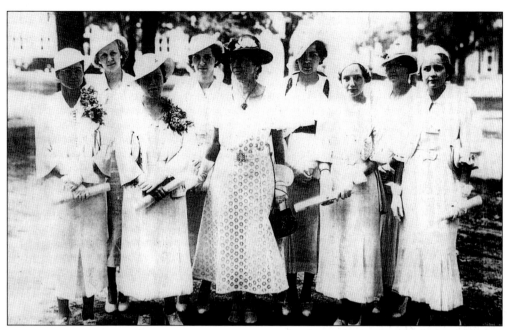

GRADUATION. These 1934 home economics graduates proudly pose with department head Louise Phillips Glanton, who had studied at Columbia and Yale Universities and the Sorbonne. She expanded the types of studies in the home economics curricula. Four years prior to this photograph, Glanton served on the White House Conference on child health and protection. Pictured front, from left to right, are the following: (front) Lois Brown, Mildred Thomas, Glanton, Lucille Johnson, and Carlton Tompkins; (back) Marion Richardson, Edna Smart, Grace Carlson, and Mrs. Edna McGowan.

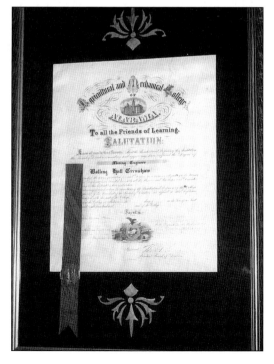

DIPLOMAS. Auburn students look forward to receiving their diplomas. Early graduates proudly displayed large, elaborate diplomas. At first, diplomas were printed on sheepskin, and then parchment was used. Professors heading departments signed diplomas. This diploma belonged to Bolling Hall Crenshaw, a mathematics professor and a member of the triumvirate that presided at Auburn during the Depression. It can be seen with another Auburn diploma he earned, which is displayed at the Crenshaw House on College Street—currently a bed and breakfast where guests have included Nobelists, world leaders, and celebrities. Early diplomas bore an image of Old Main or Samford Hall according to when the student graduated. Because he graduated before and after the 1887 fire, Crenshaw's diplomas show both buildings.

111

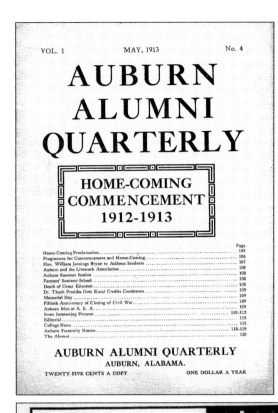

VOL. 1 MAY, 1913 No. 4

AUBURN ALUMNI QUARTERLY

HOME-COMING COMMENCEMENT 1912-1913

AUBURN ALUMNI QUARTERLY
AUBURN, ALABAMA.
TWENTY-FIVE CENTS A COPY ONE DOLLAR A YEAR

HOMECOMING. Since the early 20th century, many alumni have returned to Auburn to participate in alumni festivities, often scheduled to coincide with a significant athletic event. The *Auburn Alumni Quarterly*, then its successors, *The Auburn Alumnews* and *Auburn Magazine*, report when specific classes have reunions scheduled. Homecoming is usually celebrated in the autumn and often is a week-long celebration of concerts, celebrity visitors, and activities for students, staff, faculty, alumni, and their families to enjoy. Homecoming day is celebrated with a game, half-time show, and crowning of Miss Homecoming.

NOSTALGIA. Alumni activities include Auburn Clubs in the United States and internationally. The Lee County Auburn Club has a large membership because it is the county where Auburn is located. As a result, Auburn's outstanding coaches, athletes, faculty, and administrators are able to participate in fund-raisers and rallies close to home.

Eight

SPORTS

BRAVADO. This fierce tiger printed in the sports section of the 1923 *Glomerata* demonstrated school spirit for a team that "fell one game short of winning the southern championship." The yearbook praised as follows: "Every man on the team fought hard and clean throughout the season and more than deserved every honor that he received."

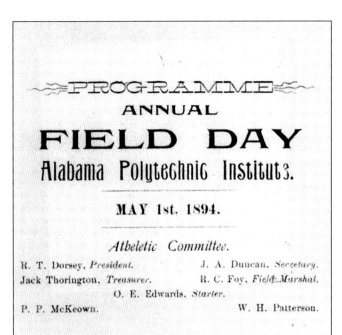

GAMES. Auburn's field days consisted of formal contests including dashes, high jumps, and pole vaulting and fun competitions such as egg and three-legged races and greased pig chases. Athletes participated to demonstrate their prowess, probably to impress coeds, and indulged in more frivolous games to relax and enjoy the companionship of friends.

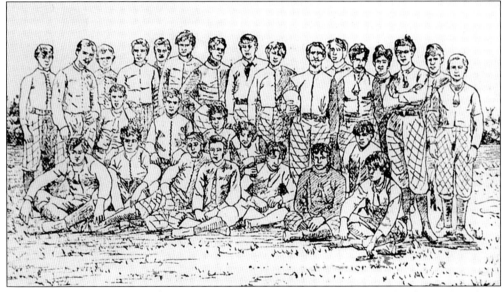

MEDIA. The November 4, 1894 *Montgomery Advertiser* published this sketch of an early Auburn football team for their match with Vanderbilt. That team included Cliff Hare, who later became a coach and chemist on campus. The football stadium was later named in his honor (eventually adding Jordan for national champion Coach "Shug" Jordan). Newspaper coverage at that time provided detailed game play and information about players. Auburn's team was praised for its hospitality. The newspaper reported Vanderbilt player W.W. Craig saying, "We have never met a more gentlemanly set of young men than the boys on the Auburn team. They play clean ball. They show themselves anxious on every occasion to do what is fair and were always willing to abide by the decisions of the referee and umpire."

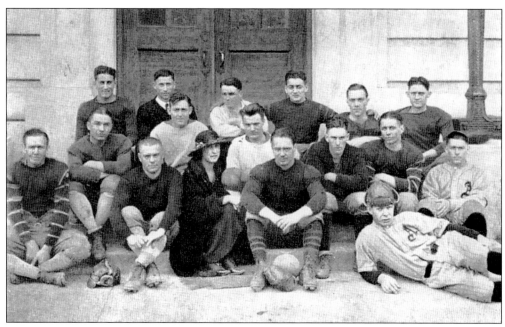

Class Teams. In addition to the varsity squad, Auburn classes manned football teams. This 1922 sophomore-class team is pictured with sponsor Miss Mary Tamplin. The juniors beat them 12-2 in the only game they played.

Inspiration. This *Glomerata* poem glorifies Auburn athletes with poetic lines using all of the letters in the words "The Auburn Football Team." Unfortunately, the author is not identified. In addition to literary creations, Auburn's football team inspired practical products. Paul Bernard Williamson '12 used his Auburn education and love for sports to develop a nationally syndicated scientific football rating system that was praised for its high accuracy and used by such notable football figures as Walter Camp.

GLOMERATA

The Auburn Football Team

The deeds of the strong are immortal,
Heroic forever they live,
Eternal reward do they give.

Auburn, thy sons are heroes;
Under the Orange and Blue
Beats not a heart but is true.
Under thy flaming colors
Rise we to do or die—
Not one of us but will try.

Football, in which we shall conquer,
Our means of revenge shall be
Over all who shall dare to question
Thy glorious sovereignty.
Break forth, ye stalwart giants,
And carry our ball to the goal;
Loud then will our shouts be of victory,
Lo, the greatest that ever was told.

Team, may you always conquer!
Ever the victory win,
And we our support do pledge you,
Mighty and brave-hearted men.

A T H L E T I C S

DONAHUE. Michael J. "Iron Mike" Donahue coached some of Auburn's most outstanding early teams from 1904 to 1922 (except in 1907 when Wiliam S. Kienholz was coach.) He urged players to be dedicated, determined, and disciplined. Most of all, he wanted them to play fairly. A Yale graduate, Donahue taught mathematics in addition to being Auburn's athletic director. He also was head professor of physical education during his later years at Auburn. Donahue was the first Auburn person inducted into the National Football Hall of Fame.

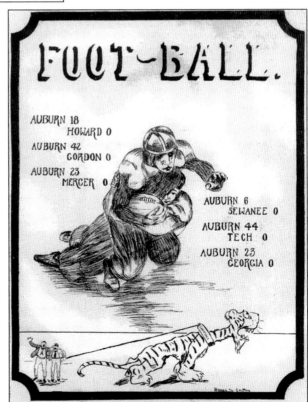

PERFECT. The 1909 *Glomerata* paid tribute to this winning season on the gridiron in which the opponents scored no points against Auburn.

116

COEDS. Coeds were as enthusiastic about football as their male counterparts. The 1901 *Glomerata* included this drawing of an Auburn coed dressed in an orange-and-blue–striped football uniform. A similar image that resembles Gibson Girls of that time can be seen near the entrance of the Lovelace Athletic Museum & Hall of Honor.

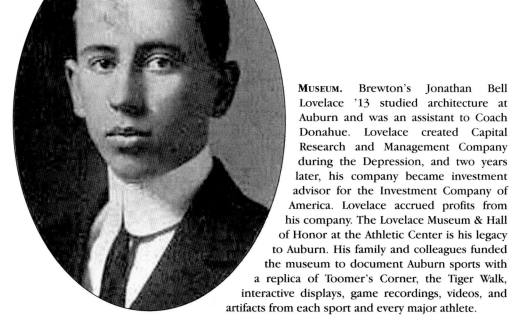

MUSEUM. Brewton's Jonathan Bell Lovelace '13 studied architecture at Auburn and was an assistant to Coach Donahue. Lovelace created Capital Research and Management Company during the Depression, and two years later, his company became investment advisor for the Investment Company of America. Lovelace accrued profits from his company. The Lovelace Museum & Hall of Honor at the Athletic Center is his legacy to Auburn. His family and colleagues funded the museum to document Auburn sports with a replica of Toomer's Corner, the Tiger Walk, interactive displays, game recordings, videos, and artifacts from each sport and every major athlete.

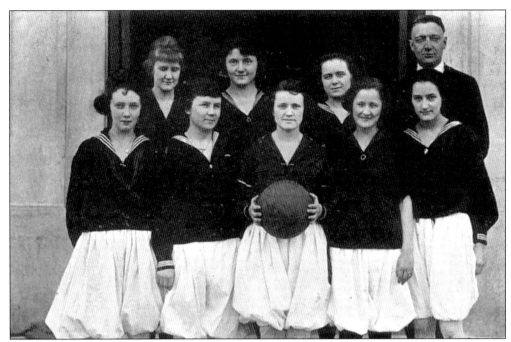

WOMEN BASKETBALL. The 1920 co-ed basketball team, coached by L.S. Phillips with team captain Kate Floyd, is pictured. Robbie Smith Sparks '22, a guard on the first women's basketball team, wrote a master's thesis in 1935 that recorded facts and lore about Auburn's history. Auburn's women's basketball teams have achieved numerous victories, especially under Coach Joe Ciampi and with such players as the Bolton sisters, Ola Mae and Ruthie. Teams have won conference titles and competed in the NCAA National Championship game.

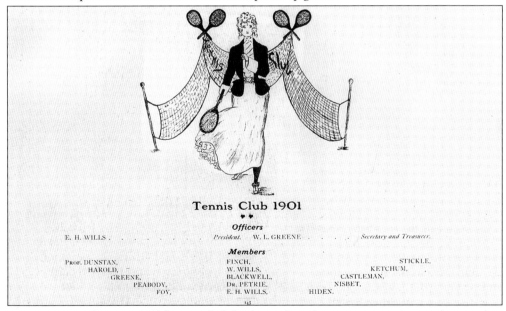

Tennis Club 1901

Officers

E. H. WILLS *President.* W. L. GREENE *Secretary and Treasurer.*

Members

PROF. DUNSTAN,	FINCH,	STICKLE,
HAROLD,	W. WILLS,	KETCHUM,
GREENE,	BLACKWELL,	CASTLEMAN,
PEABODY,	DR. PETRIE,	NISBET,
FOY,	E. H. WILLS,	HIDEN.

GOOD SPORTS. The Tennis Club provided faculty and students opportunities to play matches for fun. Recreation enabled friendships between professors and students to form and continue after graduation.

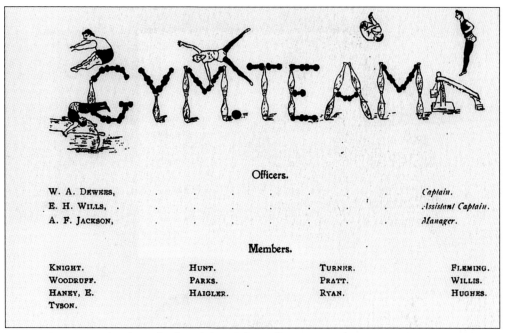

Officers.

W. A. DEWEES,	*Captain.*
E. H. WILLS,	*Assistant Captain.*
A. F. JACKSON,	*Manager.*

Members.

KNIGHT.	HUNT.	TURNER.	FLEMING.
WOODRUFF.	PARKS.	PRATT.	WILLIS.
HANEY, E.	HAIGLER.	RYAN.	HUGHES.
TYSON.			

LIMBER. Gymnastics has been both a club and formally recognized sport at Auburn. At one time, Auburn fielded a men's gymnastic team. The women's team has persevered, and members continue to achieve national recognition into the early 21st century.

DAC. John Cunningham Postell Jr. '12 was a chemistry and metallurgy major from Savannah, Georgia. A member of his freshman class football team, Postell continued his passion for that sport. He served as president of the fabled New York City Downtown Athletic Club (DAC), which sponsored the Heisman Award. When Postell retired from the DAC presidency in 1953, he was presented the Hearst Medal for leadership in Manhattan.

NCAA. Not only was Albert B. Moore '11 a renowned historian who wrote classic Alabama-themed books, he also served as NCAA president from 1953 to 1954. Another Auburn alumnus, Dr. Wilford S. Bailey '42, was the NCAA president from 1987 to 1988.

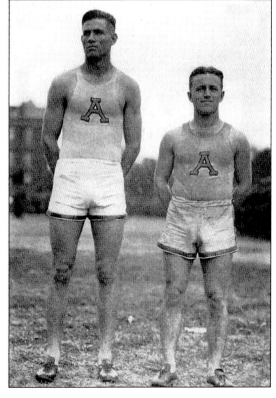

CONTRASTS. Auburn's 1927 track captains W.O. "Weemie" Baskin and W.L. "Shorty" Morrow were among Auburn's outstanding athletes. Baskin was the "greatest cinder path artist Auburn has ever turned out," setting records in hurdles and competing in javelin, high jump, shot put, and discus. He was described as "Big hearted, a sturdy trainer, a graceful athlete and a true gentleman." Morrow ran cross country and the mile. He was the 2-mile record holder at Auburn. The *Glomerata* stated, "Though small in stature, this diminutive distance man is one of the most faithful of Coach [Wilbur] Hutsell's artists" due to his "short but steady legs."

A Club. Accomplished Auburn athletes are selected for membership in the A Club. These 1923 members represent football, baseball, track, and basketball.

Hitchcock. Jimmy Hitchcock, captain of Auburn's undefeated 1932 team, received his All-American certificate at the Tournament of Roses on January 2, 1933. He is pictured below, to the left next to Pittsburgh's player Warren Heller, Pop Warner, Cristy Walsh, Ernie Smith of the University of Southern California, and Stanford's William Corbus. Hitchcock Field, named in his and his brother Billy's honor, at Plainsman Field was named America's best collegiate ballpark in a 2003 *Baseball America* survey of coaches and media directors.

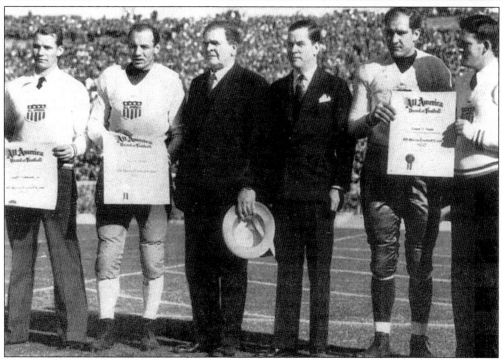

AQUATICS. Howard Morris '35, an Auburn student, served as Auburn's first swim coach when the team was established in 1932. Since his leadership, Auburn has benefited from many outstanding swimming and diving coaches, including Eddie Reese who was the national team's coach at the Olympics, Richard Quick, and John Asmuth. David Marsh, Jeff Shaffer, and Kim Brackin guided teams to NCAA national championships. Both the men's and women's swim teams have won this title. Auburn's first official swimming athletes, known as the Tank Team, began competing during the 1932 season. Notable Auburn swimmers include gold medallist Rowdy Gaines and world champion Bill Pilczuk, whose 1998 victory was lauded by *USA Today* as the "Upset of the Decade."

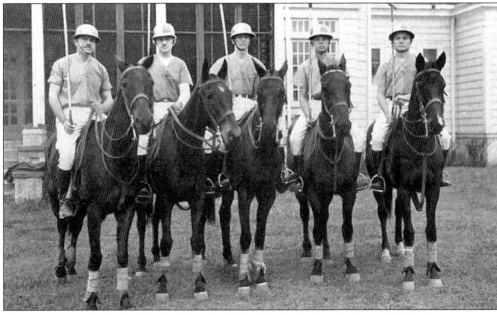

POLO. Most people think of football, basketball, or baseball when Auburn athletics is mentioned. During the 1930s, Auburn fielded polo teams. Students learned horsemanship skills to play teams from nearby Fort Benning and other schools. At that time, horses were still used for some cavalry maneuvers and many officers valued riding prowess. Horses were popular on campus. The military units stabled horses adjacent to campus. Coeds enrolled in riding classes and competed in horse shows and gymkhanas. Male students displayed their equestrian talents in informal and formal polo matches. The 1934 team and their mounts are pictured.

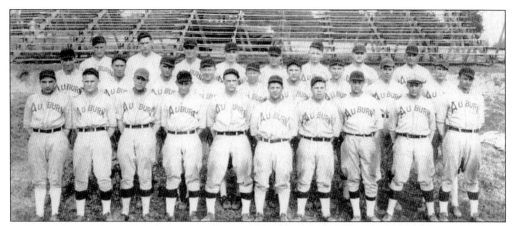

BATTER UP. Auburn has consistently fielded winning baseball teams, and some players have pursued professional playing careers. This 1931 team was the Southern Conference Champions and Dixie League Champions. Coach Sam McAllister guided such versatile players as Ralph Jordan and Jimmie Hitchcock, who were also on the football squad. Auburn's notable professional baseball players have included Billy Hitchcock, Frank Thomas, and Bo Jackson.

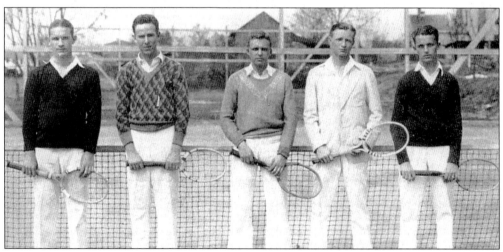

RACKETS. Auburn's first official tennis team was named in spring 1929, when coach Dr. Kimbrough recruited members. Auburn's best player, Howard Halse, competed in the Southern Conference tournament at New Orleans. He played for Auburn the next season with returning team members Carl Nicholson and Joe Smith and new players George Averill, G.W. Smith, and Clyde Seale. Players won the 2002 NCAA men's doubles championship.

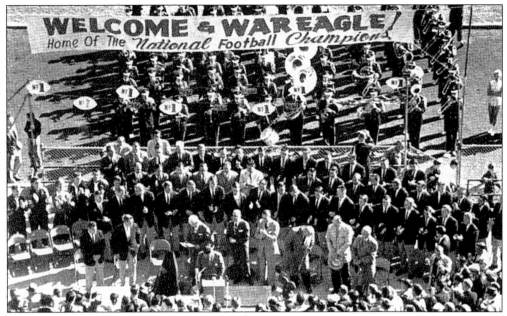

PRIDE. Auburn fans were ecstatic when the football team won the 1957 national championship. The band played at the trophy presentation. Fans strung banners and gathered at Toomer's Corner to celebrate the team. Coaches and members of that team occasionally hold reunions and are held in esteem at Auburn. Co-captain Jimmy Phillips was inducted into the Alabama Sports Hall of Fame. Neil Ennis "Dick" McGowen '41 was a notable member of that team's coaching staff. In 1939, he had thrown the first touchdown pass in the new Auburn Stadium (modern Jordan-Hare) and is also in the Sports Hall of Fame.

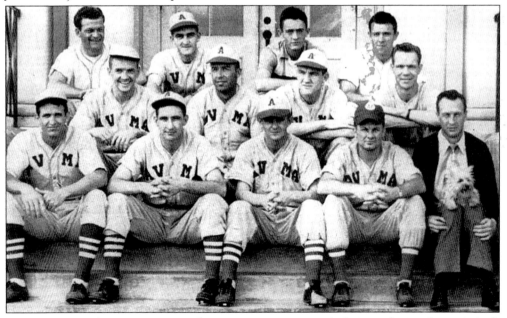

STUDENT TEAMS. These veterinary students, wearing jerseys with their professional association's initials, competed with other student teams on campus. These contests foreshadowed the establishment of intramural leagues.

124

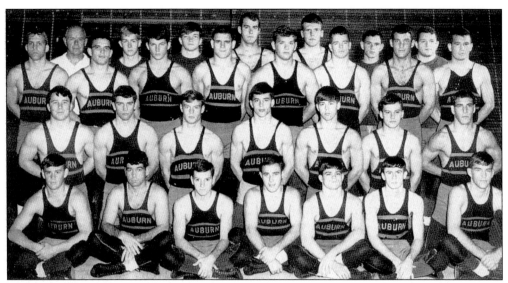

WRESTLING. Arnold "Swede" Umbach became Auburn's wrestling coach in 1946. Considered America's "winningest" wrestling coach, he coached four national champions (Dan McNair '53 was Auburn's first wrestling national champion) and his Auburn team won many Southeastern Intercollegiate Wrestling Association titles. Auburn hosted the 1971 NCAA Wrestling Championships. Umbach's wrestlers included future astronaut James S. Voss '72 and transistor inventor Harry Knowles '51. Umbach was inducted in the Wrestling Hall of Fame. Auburn terminated wrestling in 1981, but student wrestlers determined to wrestle compete in club tournaments.

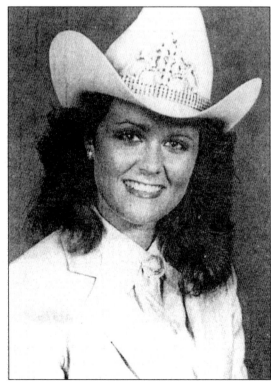

HORSES. After a series of horsemanship tests, Linda Belsterling '84 was named Alabama Senior Rodeo Queen in March 1983 and competed in the Miss Rodeo America contests at the National Rodeo Finals in Oklahoma City. Other notable Auburn equestrians who competed at a national level include Julia Markham '87, who earned a World Championship with her Quarter Horse, and Christi Stewart, who won an Appaloosa National Championship. Former Auburn student and art patron Susan Phillips exhibited championship Saddlebreds. Sanders Russell, a baseball and tennis athlete at Auburn, raced harness horses, setting world records and winning that sport's most prestigious race, the Hambletonian, in 1962. Russell was inducted into the Alabama Sports Hall of Fame.

FAIR PLAY. In 2003, Auburn's softball field was named for Dr. Jane B. Moore, a retired professor and director of graduate studies in Auburn's Department of Health and Human Performance. Moore was the first woman to chair the faculty committee on intercollegiate athletics. Only three campus sports facilities are named for Auburn academicians: Moore, James Martin, and Cliff Hare. Moore is pleased with the women's athletic programs at Auburn because they are "fully funded with scholarships" and "many of the head coaches are women, and all teams have women assistant coaches." She notes, "Most of the facilities are state of the art. We have a culture of equity at Auburn and all athletes are given equal opportunity to excel in their sport."

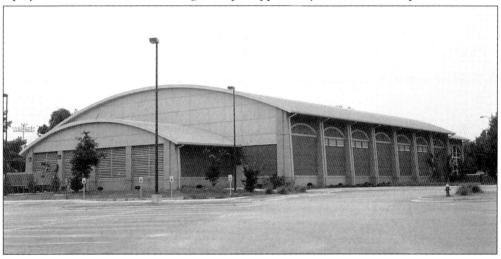

GYMNASIUM. The Earlon and Betty McWhorter Center for Women's Athletics was funded when Auburn trustee McWhorter gave $2.5 million after the Auburn Sports Arena burned down during the 1996 Auburn-LSU football game. The new gymnasium built in 1999 provides softball and gymnastics practice space, locker rooms, and training areas. The gymnasium hosts summer camps for children and teenagers.

Intramurals. Wendy King Carriger '91, an electrical engineering student from Huntsville, strives to score for her sorority, Zeta Tau Alpha, during an intramural flag football game in fall 1988. Both Greeks and independents fielded teams for a variety of intramural sports, including basketball, tennis, softball, volleyball, swimming, bowling, ping-pong, billiards, racquetball, and track. Faculty and staff also formed intramural leagues. Participants enjoyed athletic activities to help them relax between classes, keep fit, and develop friendships. Games and tournaments were played at the Intramurals Field and Student Activities Center. The Department of Recreational Services and Athletic Department gave awards such as the All Sports Trophy to tournament winners.

Equestrian. Auburn has had a long history of interactions with horses, offering physical education classes in equitation, fielding a polo team, and utilizing horses for military maneuvers and for veterinary education. The school's first varsity equestrian team participated in its first season of competition in 2003. Head Coach Greg Williams, whose father is the entomology department head, prepares the team of students and horses with skilled farrier and trainer Herb Schneider. At the 2003 Intercollegiate Horse Show Association Nationals, Auburn's team ranked 5th in Hunt Seat competition and 12th in Western classes. Williams is pictured with a team member and her horse.

TRIBUTE. When longtime Auburn Network sports announcer Jim Fyffe died on May 15, 2003, the Auburn community was stunned. Fyffe's jubilant "Touchdown Auburn!" was beloved by fans who listened to his play-by-play coverage of Auburn football for 20 seasons, many of them championship years such as the undefeated 1993 team. He also announced Auburn basketball games. Anders Bookstore (http://www.anders-bookstore.com), a downtown supplier of textbooks, clothing, and souvenirs since the 1950s, posted this tribute to Fyffe. The Anders family has long supported Auburn athletics. Ron Anders '86 was a cheerleader. He and his father, Ronnie Anders, provide a variety of services in their Magnolia Avenue store across the street from campus. The Anders Society offers game shirts and discounts for members. The annual Anders Spectacular Beat Bama Sale is an example of the Anders family's outstanding Auburn spirit. A new Auburn tradition began during the 2003 football season when fans shouted "Touchdown Auburn!" every time the team scored, in memory of Fyffe.